NIÑO FIDENCIO

A Heart Thrown Open

*Photographs
and Interviews by
Dore Gardner*

*Essay by
Kay F. Turner*

Museum of New Mexico Press

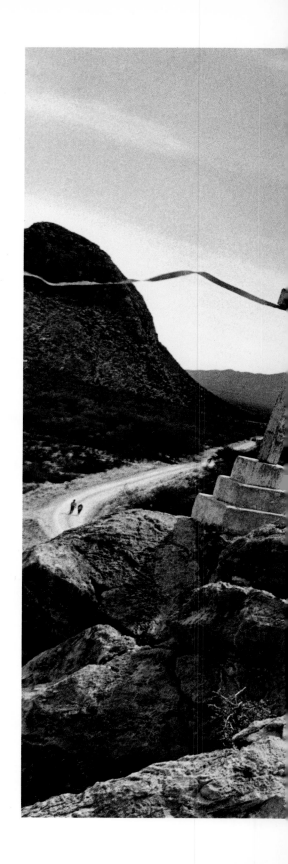

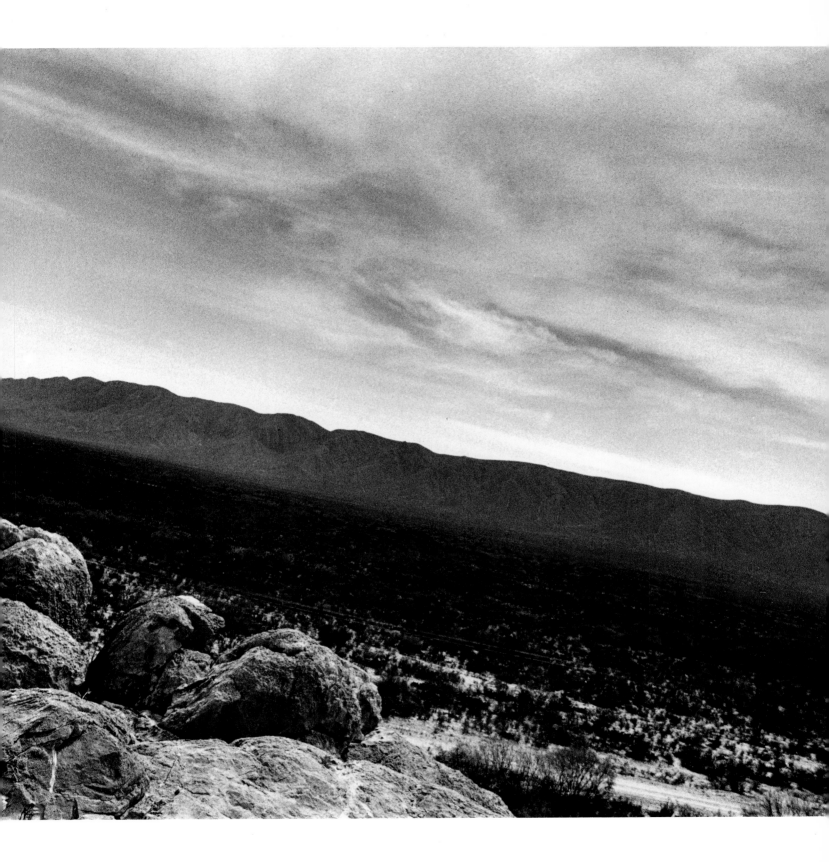

Acknowledgments

I am deeply grateful to all the people I photographed on both sides of the Rio Grande who so generously opened their homes and hearts to me, especially: Alma Martínez, whose faith made the impossible possible and without whom I simply could not have completed this work; Emma Gonzales and Ma. Elena Oñate for inspiration; Pedro Angel Gonzales and the López de la Fuente family at the *tumba*; Nicolosa Henry, Elodia Jiménez, Albino Martínez, Armando and Emily Musquiz, and their misión; Francisca Monsivaíz, the Reverend Alberto and Lydia Salinas for nourishing body and soul; Anita Rodríguez and her misión; Paul Rámos, Richard Zelade, Armandina A. Zuniga, and the Riojas family; Angela Salazar and her misión; and Pedro Ramón, who first led me to her.

There are many others I wish to thank who generously gave support, encouragement, and assistance during the five often-difficult years it took to complete this work, especially: Raquel Bauman, Mario Montaño, and Kay Turner, whose valuable insights guided me very early on; Janet Walsh, who first proofread a very long, unpuctuated text; Mary Wachs, my editor, who believed in this work from its inception, set this book in motion, and saw me through its long delivery with humor and sensitivity; and Eleanor Caponigro for her design of the book. To my parents, Robert and Judith Gardner, and sister, Deborah Gardner, for their support at crucial times. To Christopher Brown, Brian Murphy, and David duBusc for their companionship on the road; Jean Caslin at the Houston Center for Photography; and to my printers John Marcy, Nicole Burkhart, and Zoe Perry. Thanks to Julie Graham, Mimi Hirsh, David Montenegro, Juan Gonzáles, Polly Brown, Nina Davenport, Karl Baden, and Suzi Noble for the countless ways they helped to complete this book.

Above all else to David Deans for simply being there.

I wish to express appreciation to the Threshold Foundation, especially Stephanie Smith and Holton Rower, and the LEF Foundation and Michael Moore for their support enabling me to bring this book to completion; and to AMI Inc., the Ludwig Vogelstein Foundation, Blanche Colman Trust, and the Marblehead Arts Council in conjunction with the Massachusetts Artist Lottery for their support in the early stages of this project.

Frontispiece:
El cerro de campana, where Niño often performed mass cures. Espinazo, Nuevo León, 1987.

4

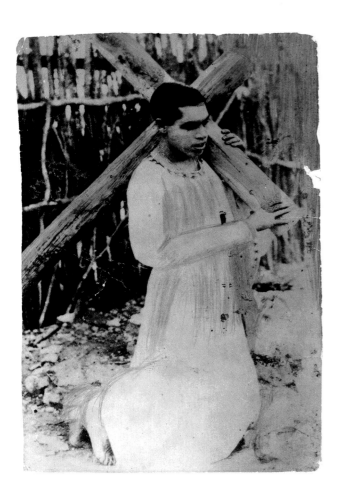

Historic images of Niño Fidencio are reproduced, sold, and traded among Fidencistas.

Foreword

José Fidencio Sintora Constantino was born in Guanajuato in 1898 and lived in Espinazo, Nuevo León, in northeastern Mexico. He came to Espinazo as a young man to work as a housekeeper in the hacienda of Enrique López de la Fuente. Members of the López de la Fuente family still live in the hacienda and maintain the tomb where he is buried.

At a young age Niño Fidencio began to show a remarkable affinity for the supernatural, healing, medicinal plants, and curing potions. By his mid-twenties thousands of people were coming to Espinazo. There they would camp out awaiting his attention and hoping to be touched by him. In 1928, it is said, he cured the president of Mexico, Plutarco Elías Calles, of a serious disease, which only increased his fame. At the time of his death in 1938, he was Mexico's most famous *curandero* (healer).

Today there are countless *curanderos* who are mediums for the spirit of Niño Fidencio both in Mexico and wherever there is a substantial Mexican-American community in the U.S. The *curanderos* are referred to as *materias* (female) or *cajones* (male) and act as *cajitas* (little boxes) for Niño's spirit. During healing rituals they are endowed with the Niño's healing powers.

During four days in October (Niño's birth and death) and again in March (his saint's birthday) the small village of Espinazo swells with thousands of people who come to pay homage to Niño Fidencio and renew their faith and healing powers. The pilgrims arrive each morning by the hundreds. From the *pirulito* tree at the edge of town they proceed to the *tumba* in groups with other members of their missions, each led by a *materia* or *cajón* dressed in a robe such as the Niño wore.

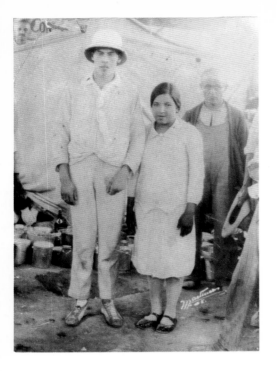

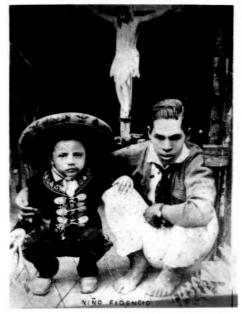

NIÑO FIDENCIO

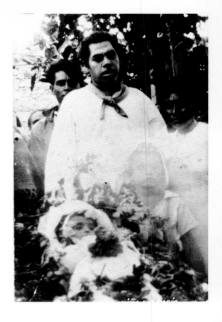

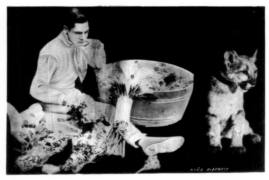

NIÑO FIDENCIO

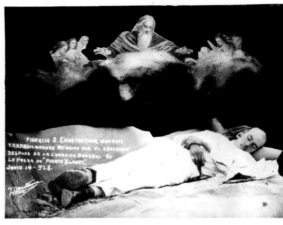

FIDENCIO S. CONSTANTINO, DUERME
TRANQUILAMENTE RENDIDO POR EL CANSANCIO
DESPUES DE LA CURACION GENERAL EN
LA PRESA DE PUERTO BLANCO.
JUNIO 14-928.

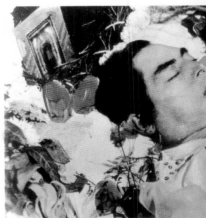

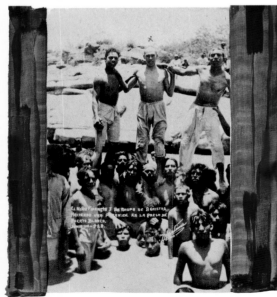

EL NIÑO FIDENCIO Y SU GRUPO DE BAÑISTAS
HACIENDO UNA PIRÁMIDE EN LA PRESA DE
PUERTO BLANCO.

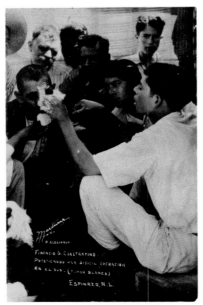

P. ASEGURAN

FIDENCIO S. CONSTANTINO
PRACTICANDO UNA DIFÍCIL OPERACIÓN
EN EL OJO. (PUERTO BLANCO)

ESPINAZO, N.L.

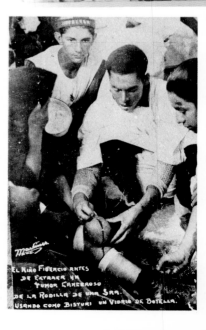

EL NIÑO FIDENCIO ANTES
DE EXTRAER UN
TUMOR CANCEROSO
DE LA RODILLA DE UNA SRA.
USANDO COMO BISTURÍ UN VIDRIO DE BOTELLA.

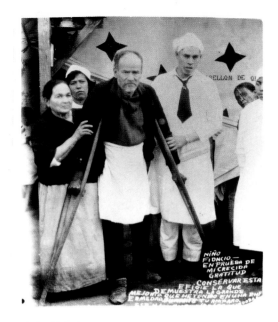

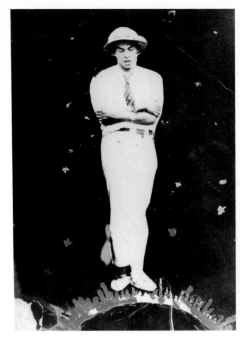

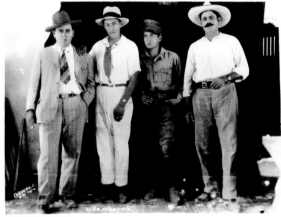

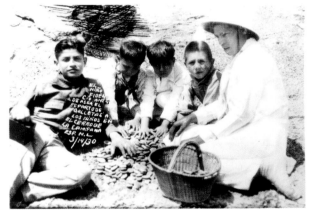

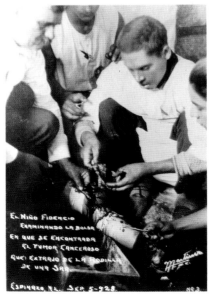

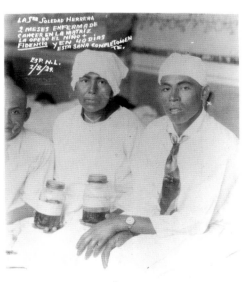

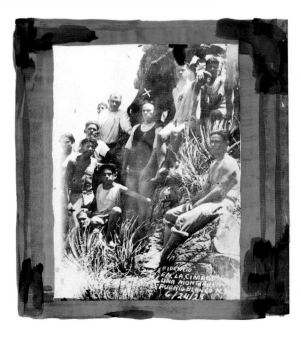

To my friend:
Dore Gardner,
A child of
the love of God.
In the picture:
Fidencio Constantino,
Ulises Lopez de la Fuente
Cardenas
(child),
+ baby-(deceased)
Dora Lopez de La
Fuente Cardenas
"We are Never Apart"
You are living close to my
heart + my mind treasures!
your memory God Bless
You Rev. Albert
Salinas
X

Rev. Albert Salinas
373-3638

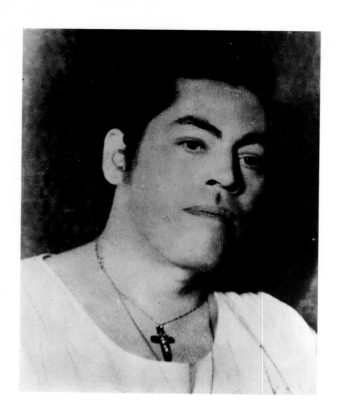

Preface

My first image of Niño Fidencio came from the documentary film *El Niño Fidencio* by Mexican filmmaker Nicholas Echevaria. The sight of thousands of people standing under a glaring sun while the Niño crawled over their shoulders, transported through the crowd, reaching out to touch all the hands outstretched toward him, moved me deeply.

I returned the following night to watch the film a second time, struck by the face of Niño Fidencio, his gaze distant yet compassionate, oddly comforting, even familiar. Though he died in 1938, I wanted to know him. I was told that many people are mediums for his healing spirit and thousands still seek his cures on both sides of the Rio Grande and make pilgrimage to his tomb in Espinazo, Nuevo León, in northeastern Mexico. I wanted to go there.

When I began this body of work in 1986, my initial desire was to include it with photographs I had been making at the time about faith and healing in the Carolinas, Georgia, and at home in Boston. The work was an effort to understand or perhaps to experience the force of living faith, something which had always perplexed and eluded me.

On Christmas 1986 I found myself standing in front of Angela Salazar's *tronito* (shrine), across the border in Nuevo Laredo, Tamaulipas, Mexico. A life-size plaster bust of Niño Fidencio stares back at me; I ask to photograph a *curación*. Come back tomorrow, she says, I must ask the Niño. I return the following day. Many gather. Angela receives the spirit of Niño and he says through her I can photograph, I am supposed to be here and they are all to welcome me.

By March 1987 I am on a train from Piedras Negras en

route to Espinazo. I carry the advice from the first *materia* I met in Marion, Texas, Antonia Suarez: trust the Niño, he will guide you.

I never met with any resistance; many were certain I was sent by the Niño to tell his story. There was always a message from the Niño for me at the *misiones* I visited. Sometimes just sweet words of encouragement; he knew how far I had traveled and how tired I was. One time a message from Bertha, my grandmother, who had been dead for thirty-four years. The *cajón* knew her name, though I'd never mentioned it, nor was it a Spanish name. He said with a twinkle in his eye, "I bring you this message so you know I am who I am."

From 1988 to 1991 I returned to Espinazo and the *misiones* throughout Texas both to photograph and to record. The old photographs of Niño I found and the

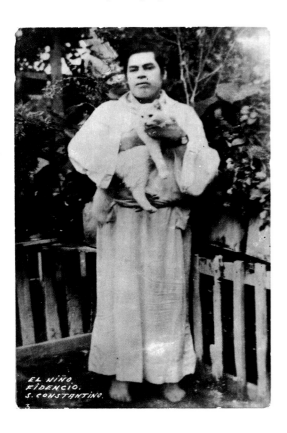

EL NIÑO.
FIDENCIO.
S. CONSTANTINO.

many stories I heard of Niño's life and testimonies to his cures were as powerful as the images I saw before me. Through the voices of the people unfolded an even more powerful story. Many of their voices are included here. They are extraordinary people. This book is for them.

When I compiled all my notes from interviews written on scraps of paper and sides of María's cookie boxes and recorded on tape, the text unfolded like an epic poem, arcing between past and present, myth and reality, suspending traditional time and space, awakening a universal sense of the sacred buried deep in the unconscious, deep within the heart.

Concurrent with my discovery of Niño Fidencio and his followers, questions about faith and healing became more immediate to me. A year into the project a physical illness took away much that I had built up over the years, leaving me, at the time, with little to hold on to except for my desire to continue this work. I was in need of some greater healing and gradually, without quite realizing it, I grew into an understanding of what had once seemed so remote and beyond my experience.

Nineteen hundred and eighty-eight was the 50th anniversary of Niño Fidencio's death and his followers are still growing in number. Some forty thousand people came to Espinazo during the four-day celebration to pay homage to the Niño, renew their powers, and reconnect with their cultural and spiritual home. They came from Mexico, California, Texas, Illinois, Ohio, Idaho, and Florida. The old *materias* of Mexico and Texas still go back and forth across the border visiting *misiones*, sharing their traditional cures, and bringing down the spirit of the Niño. The world changes all around them, but not so much here where history, culture, ritual, and memory merge and the spiritual life looms over the material world.

La cama de Niño Fidencio. Espinazo, Nuevo León,
1988.

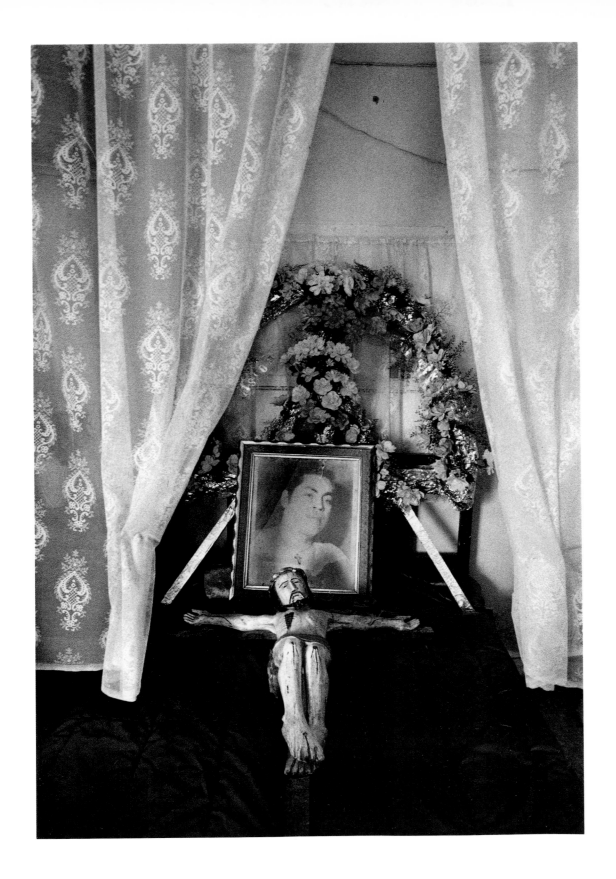

Entrance to the *tumba*. Espinazo, Nuevo León, 1987.

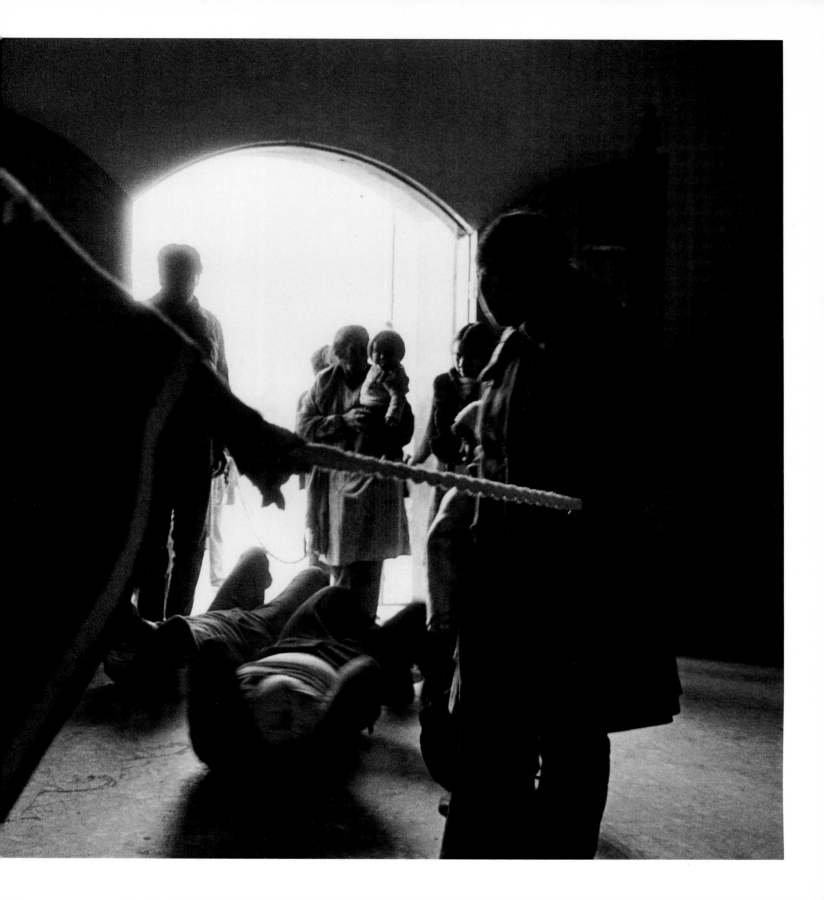

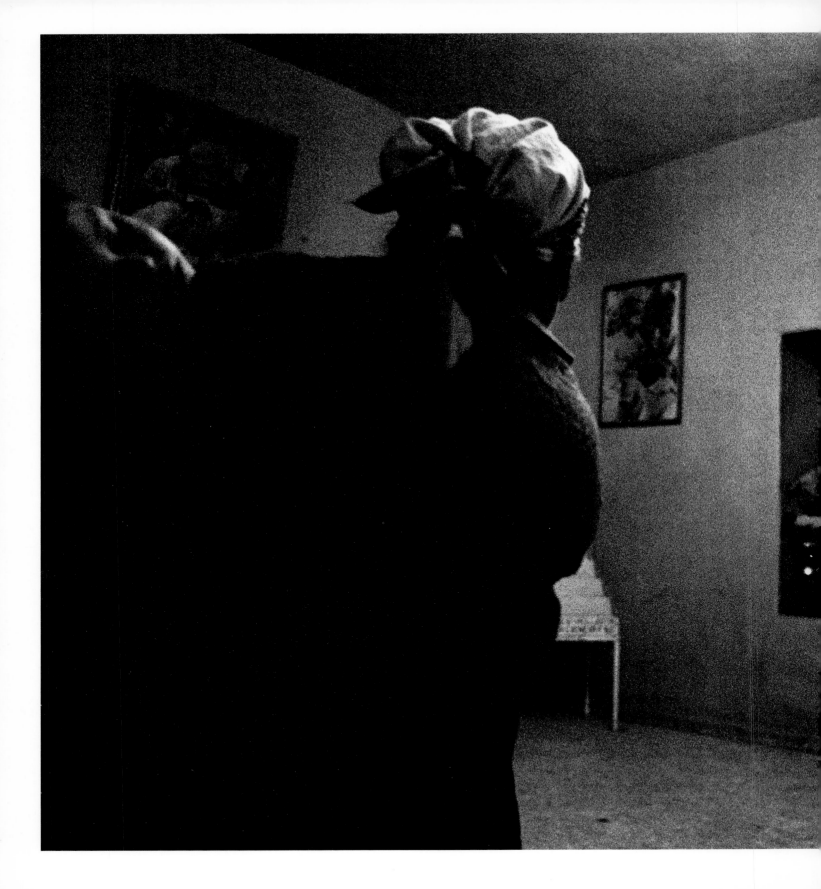

Inside the *tumba*. Espinazo, Nuevo León, 1990.

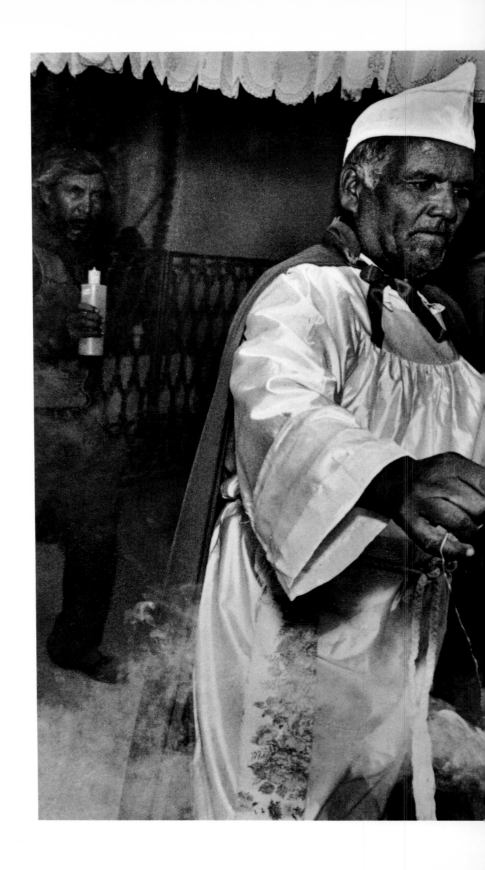

Inside the *tumba*. Espinazo, Nuevo León, 1988.

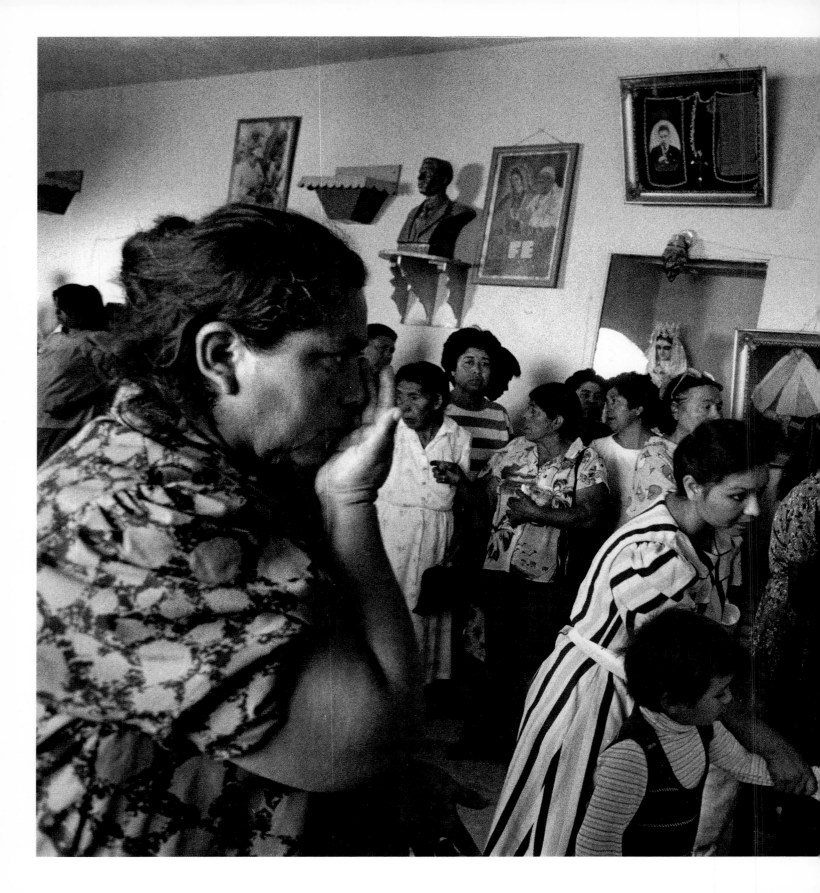

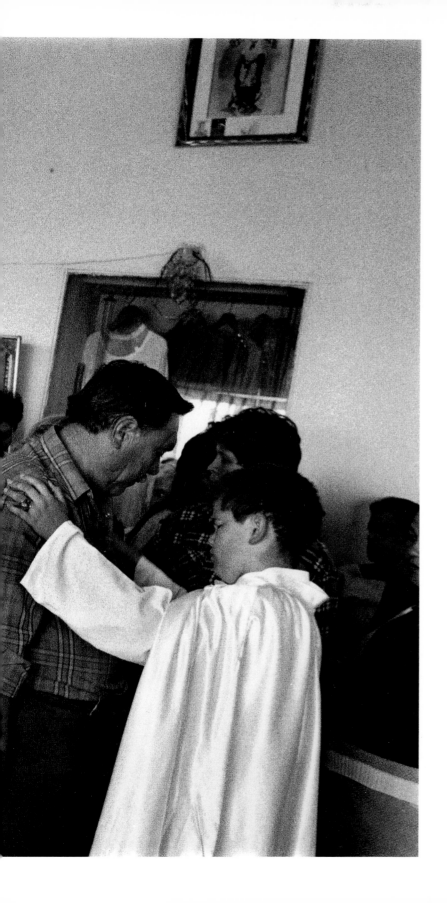

Young *cajón* healing inside the *tumba*. Espinazo,
Nuevo León, 1988.

19

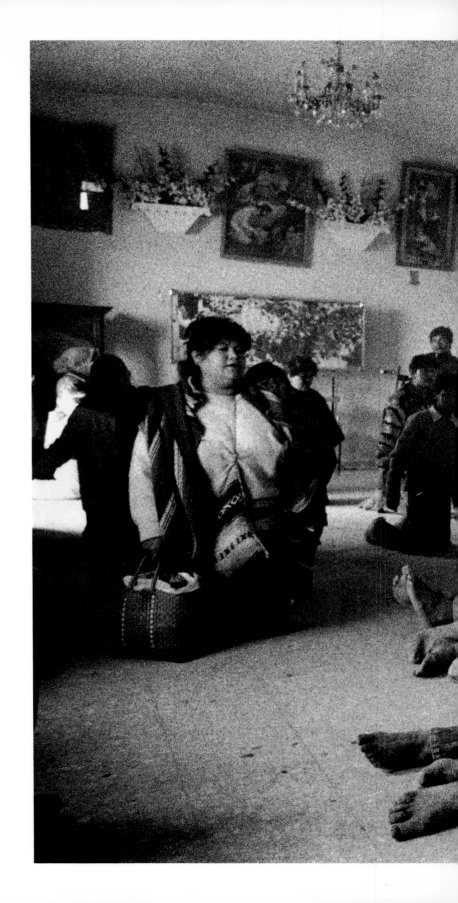

Inside the *tumba*. Espinazo, Nuevo León, 1990.

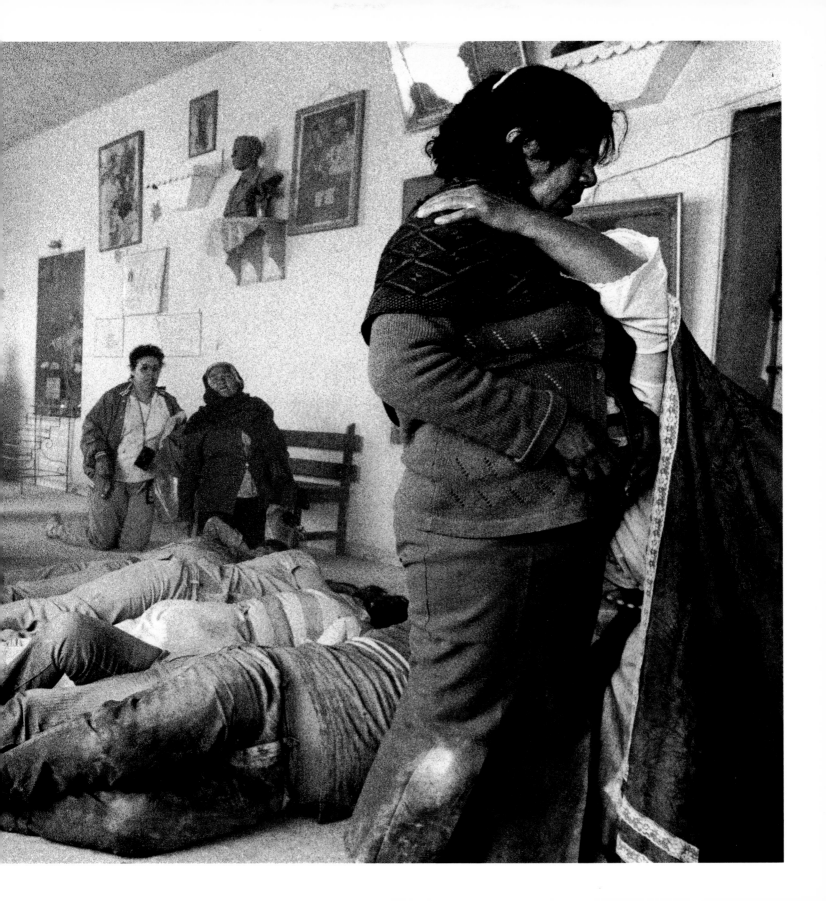

Octaviana Torres Davíla, Espinazo, Nuevo León, México

Octaviana lived in Espinazo and was one of the helpers to the Niño. She cooked for him, took care of his valuables, and cleaned up after him at the shack where he healed people with leprosy. When asked how he died she said, *because he was tired.*

Before he died he told everyone he would leave. Everyone said they wanted to go with him. He said, "Where I am going no one can go." He said he would come back spiritually, to leave him alone for three days, and on the third day he would rise again. A friend sent for doctor before three days. They couldn't wait for him. They were getting anxious. The doctors performed an autopsy before he was really dead. They killed him. He was in a trance for two days. They didn't wait till the third day.

Octaviana died September 15, 1989. They say she was 104 years old. This interview was made in 1987.

Inside the *tumba*. Espinazo, Nuevo León, 1988.

22

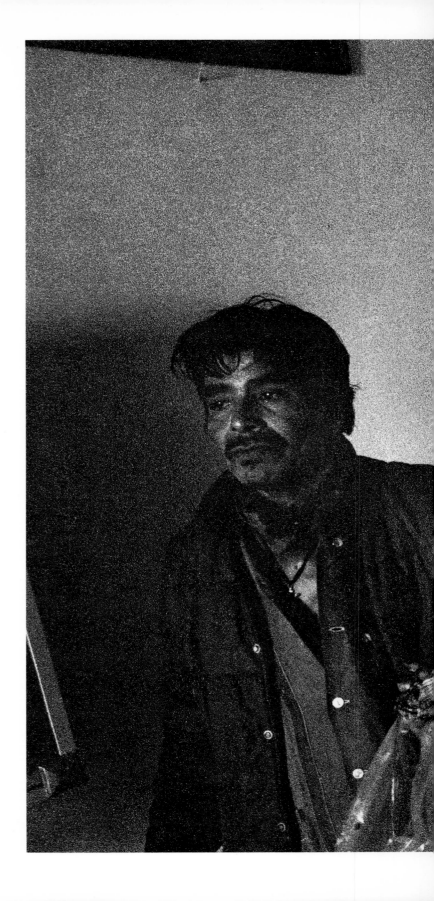

Materia Emma Gonzáles, San Antonio, Texas

If you have faith, first of all in Jesus, truly, and with the power of God, who has given Niñito the blessing. You ask Niñito for some help and ask Jesus first of all. If you don't have faith, it's no use. A lot of people say, "Niñito didn't help me." You have to have faith and your prayers will be answered. It's all done with prayers.

There are many stories about Niñito, and I guess every heart that's with Niñito has a different opinion. There's a lot of materias who do one way and who do the other way, but there is only one Niñito. Niñito is the only one who knows what he does and what he says.

I was raised in a very religious family. I never heard or read about Niñito in San Antonio. One time I was very sick. I was going to the hospital to be operated, to make a surgery, exploratory. I didn't know what was wrong.

One of my cousins had come to Niñito in Mexico. She had went to El Pavito, a place where they make penitencia in April during Holy Week. The Niñito there told my cousin that I needed help, and she was not even thinking of me and I wasn't even thinking of her.

When she got back, she called me. "Oh, don't worry," she said, "Niño will help you." I told her, "Make sure you don't come when my husband is here. He doesn't believe somebody can cure another person. He said he would divorce me if I ever tell him I want someone to cure me like that."

I didn't know then what was Niñito, I thought he was a little boy. My husband says, "Nobody can do things as good as a doctor because the doctors know better because they study and all that." He use to tell me, "Don't believe in things like that." Sometimes I use to cry, "Take me to somebody. I think I need help." He says, "No, if you need help I'll take you to another doctor, if you want.

But not to those people, not to a curandero." So long I been sick so I say okay to my cousin.

She brought a materia with her; they started curing me with pirul [branches from a pepper tree]. I was very sick. Groups of people my cousin brought from the mission, people I didn't know, were there. They had a bunch of ruda y romero [herby grass and rosemary]. They start curing me so hard with those herbs, and I was afraid. It was almost time for my husband to come home for lunch.

My husband came home. He didn't believe. My husband said, "What is all this about, what kind of cure is that hitting her with all those leaves? You are going to leave her all bruised." He was mad. He says, "If my wife has a bruise on her body, I am going to call the police."

My cousin said, "No, no, don't worry. Wait, she is going to get well." The people said he [Niño] is going to cure her and she won't have to go to the hospital.

By that time I was in a trance. Niño knocked me down and I didn't know anything about me for a little while, and when I got up I saw my husband all over my body checking my legs to see if I had a bruise, but I didn't have no bruises. They hit me so hard, I thought I'd have marks all over my body.

My cousin said, "Look, no marks."

I told him, "Don't get mad. I am cured." I could feel I was cured. I felt I had come out of something. This was thirty-five years ago.

Niñito told us through materia Olga in March we had to come to Espinazo. My husband agreed to it because he saw that I was doing better and better and working in my house and everything. So we came to Espinazo. They told us we had to bring quilts and a white dress, lots of quilts, told us how to dress. We didn't have nowhere to stay or anything, just under a tree. I didn't know nothing. I thought it was like going to Monterrey with hotels. You

had to jump and throw stuff from the windows of the train because the train was so full of people.

We had been there two or three days and my husband says, "This is the last time I come." I tell my husband this is the last time we come. We hadn't changed clothes, I didn't expect to find this, so much dust; we aren't use to all this dust. From my point, I says, "Honey, we already came, and I got well. I thank God, and I thank Niñito. I already paid my penitence, and we don't come no more."

We were walking, my husband and I, up from the pirulito [the tree where Niño got his special powers from God]. He came to pay his promise because I was in good health. We were coming up the hill. The materia covered me with his cape. I heard the Niño say, "You are not coming back?" He told us what I had just said. I was surprised. Everything we had discussed at the pirulito the Niñito told us, so I got more faith. The Niñito was coming in Padre Victor. He said, "What did you say, madrinita [godmother], that you are not coming back?"

I says, "Niñito, I already came to pay my penitencia." My husband says, "It's the last time we come." The Niñito says, "The next time we come with a big group. You are going to come working to me with a mission always because you are mine."

"No, Niñito," I said, "I don't know nothing. I don't even know how to pray in Spanish. I don't know no herbs."

Niñito says, "You going to learn. I am going to come into your heart."

My husband kept saying, "No, I can't come back." Niñito kept saying, "You can come. The next October if you don't come, you will be baldheaded," he tell my husband. My husband took it as a joke and didn't believe. We can't always have what we want.

In June we were all praying the rosary. Niñito came into my heart and started inviting people for October. By October I had a lot of people coming with me, like Niñito

said, and ever since then. I ask my husband if he was going to bring us because I don't drive, and he says, "No, you find your own way to take all those people Niñito invited in you, because I am not going."

By July, my husband's hair was falling out. All his hair was coming off. I say, "You aren't going to see Niñito?"

"I think I am going to go," he says, "look at my hair." He got all his hair back.

I was becoming a materia. It was surprising to me. Me and materia Olga were doing things together. We worked together for a long time till I came up. Every time I go over there [Espinazo] Niñito would put me through. Finally compadre Victor told me when you go back home you have to have forty days of fasting. At three o'clock in the morning take a shower with some herbs. I did it because I thought it was my medicine to be cured. It was what he gave me to be a materia.

Suddenly Niñito came one night. I cried, I was so happy. I was kind of worried because my husband was not very much a believer, but I did it for him, Niñito, anything, even if I had to lose my marriage, I would keep with the Niñito.

Thanks to God, nothing happened. My husband comes —my boys are married. We all make arrangements for our vacation in October. Ever since then, I've had so much help from Niñito. I've come all the way from Texas now for thirty-five years, two times a year. My youngest children were born in a mission to Niño Fidencio.

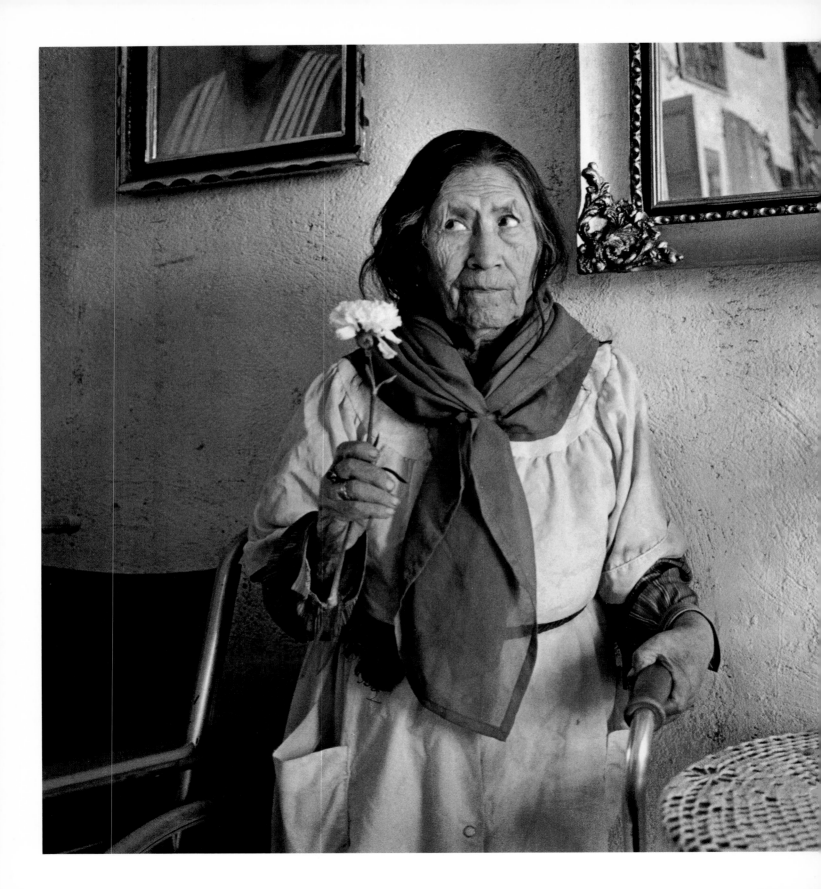

Lucita Martínez, Niño's *corista* (singer). Espinazo, Nuevo León, 1989.

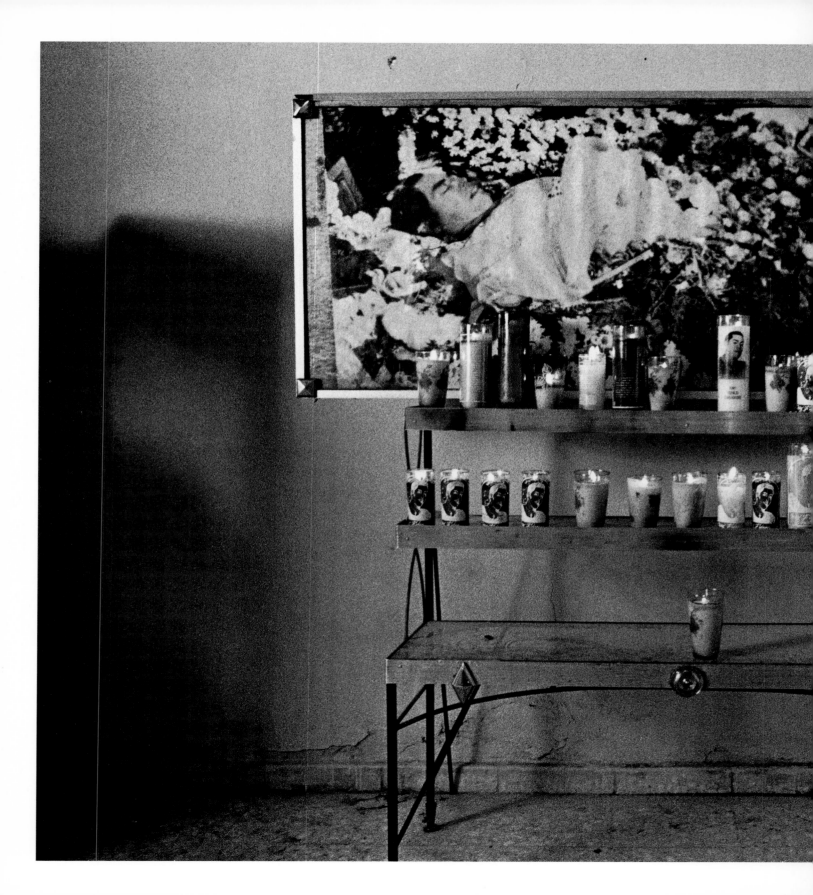

Death *foto*. Espinazo, Nuevo León, 1988.

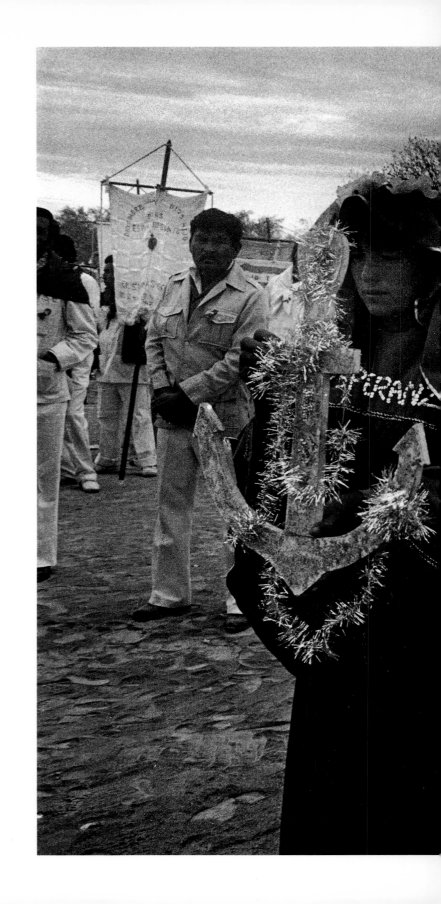

Procession at dawn to Niñito's *tumba*. Espinazo, Nuevo León, 1987.

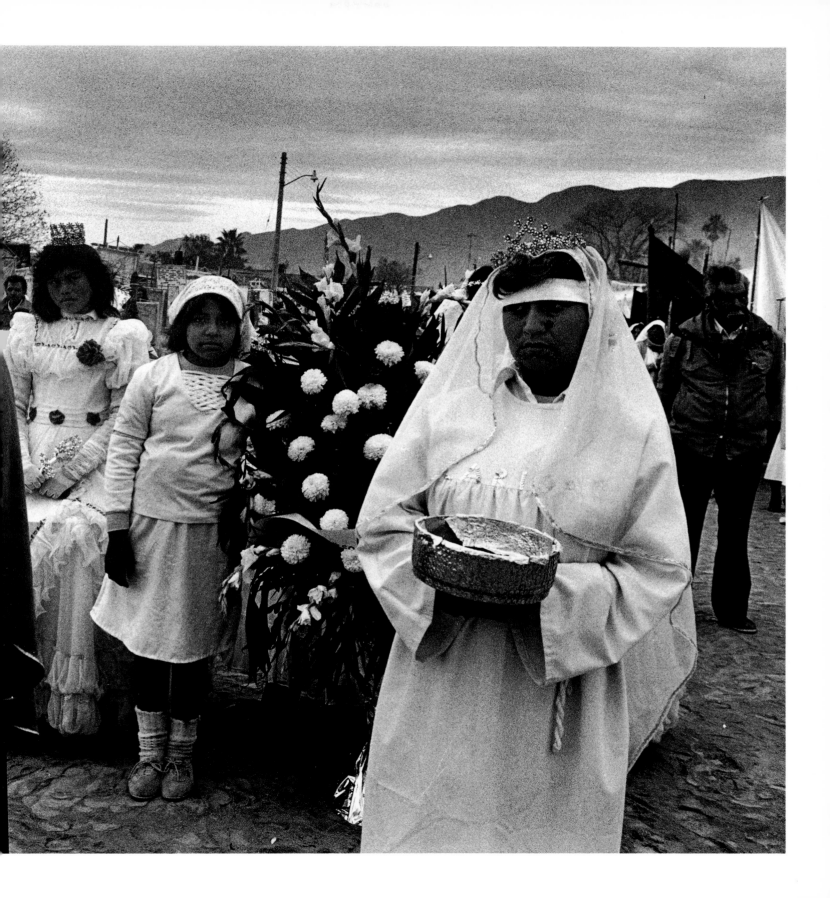

Cajón leading his mission, *el camino de penitencia*.
Espinazo, Nuevo León, 1987.

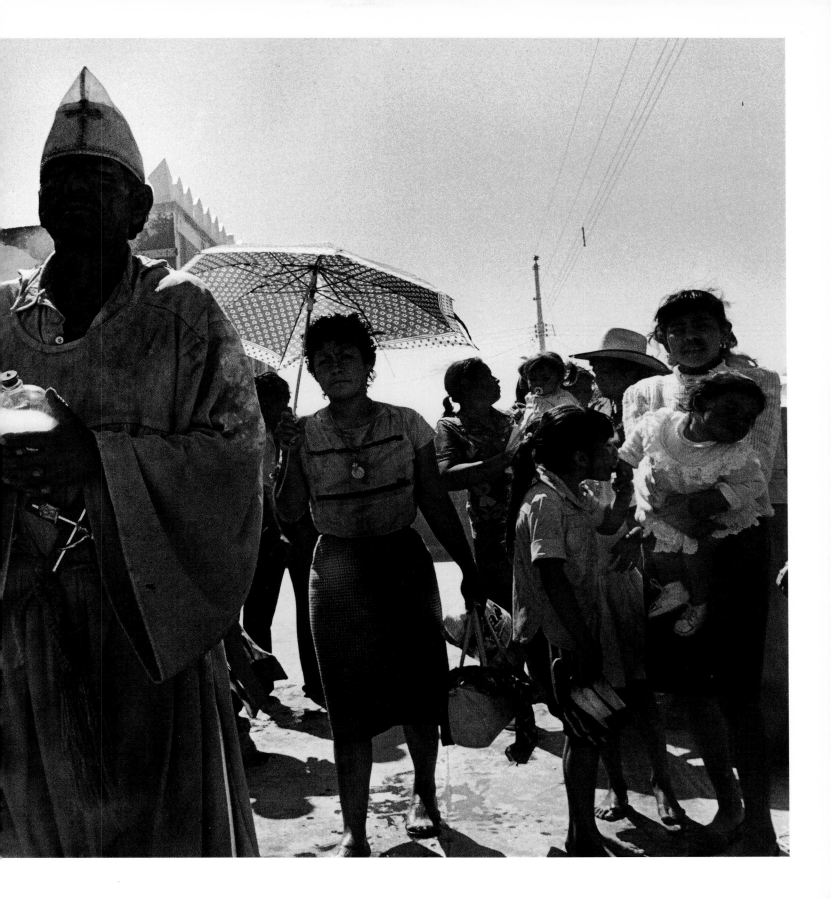

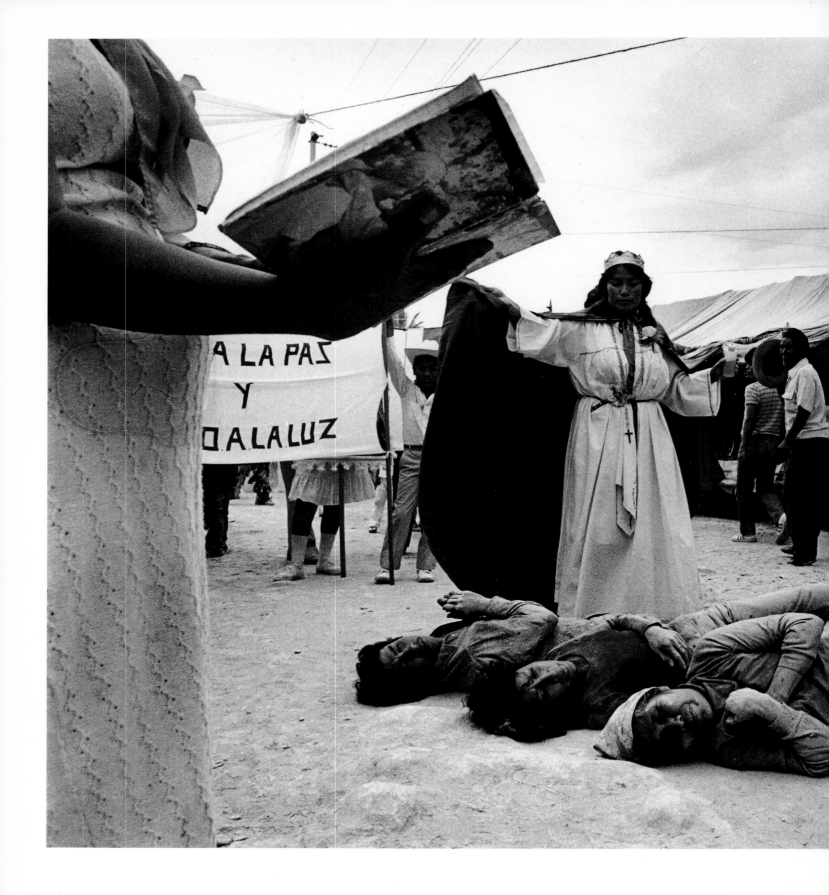

El camino de penitencia. Espinazo, Nuevo León. 1987.

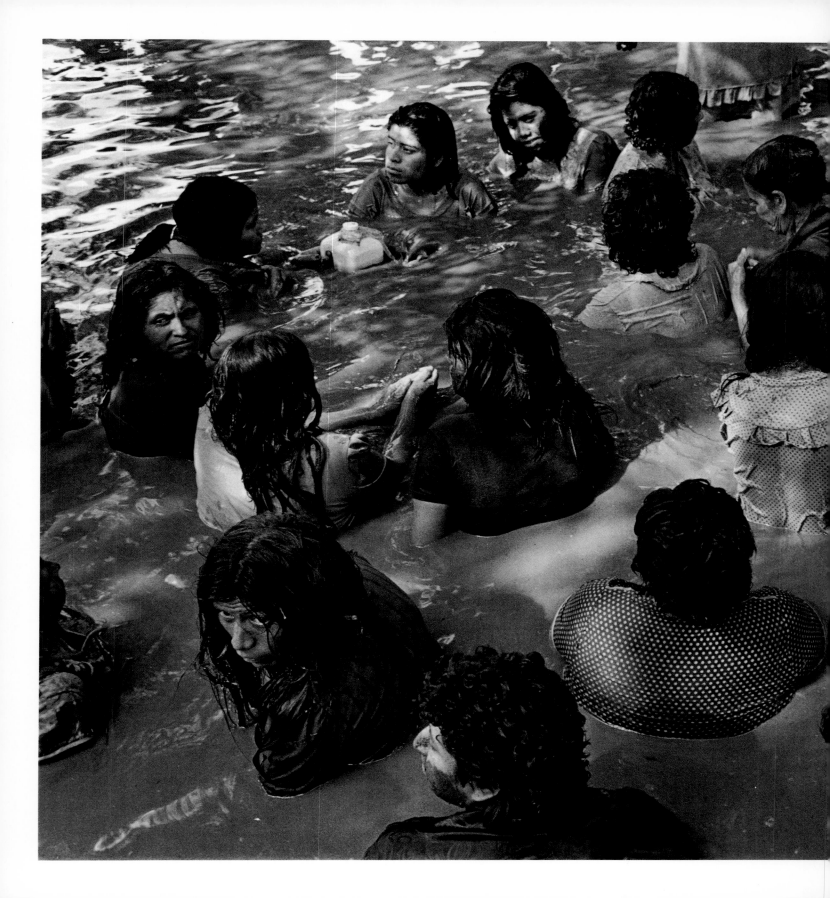

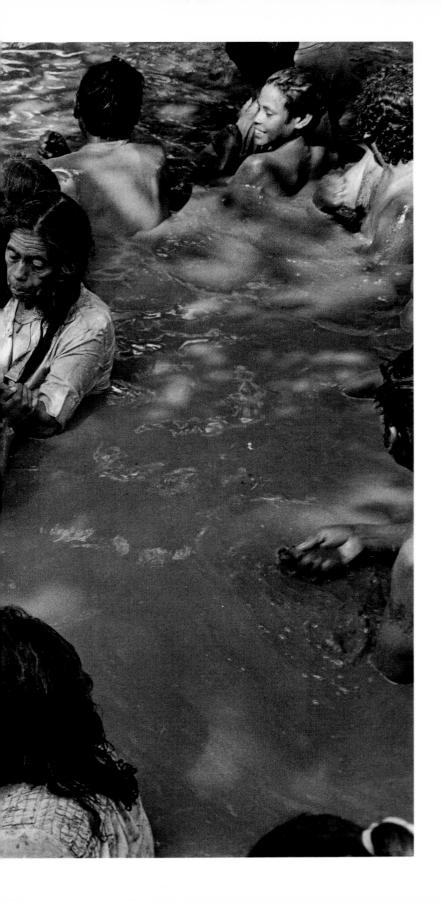

El charquito (the sacred pool). Espinazo, Nuevo León,
1988.

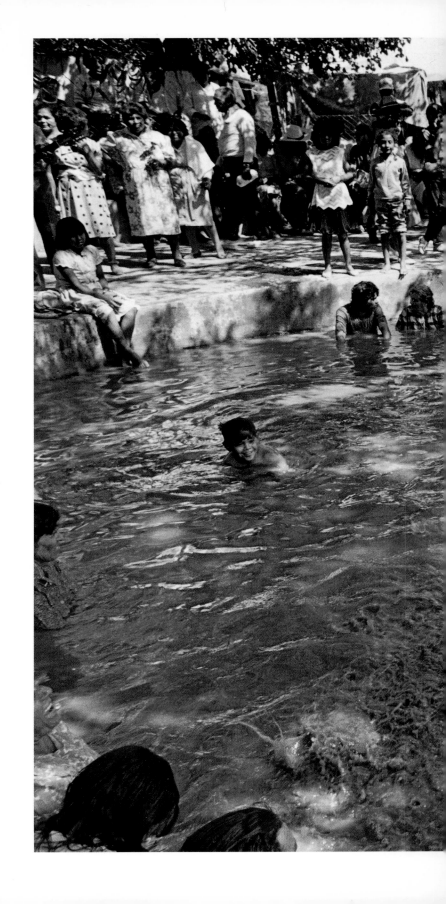

El charquito. Espinazo, Nuevo León, 1988.

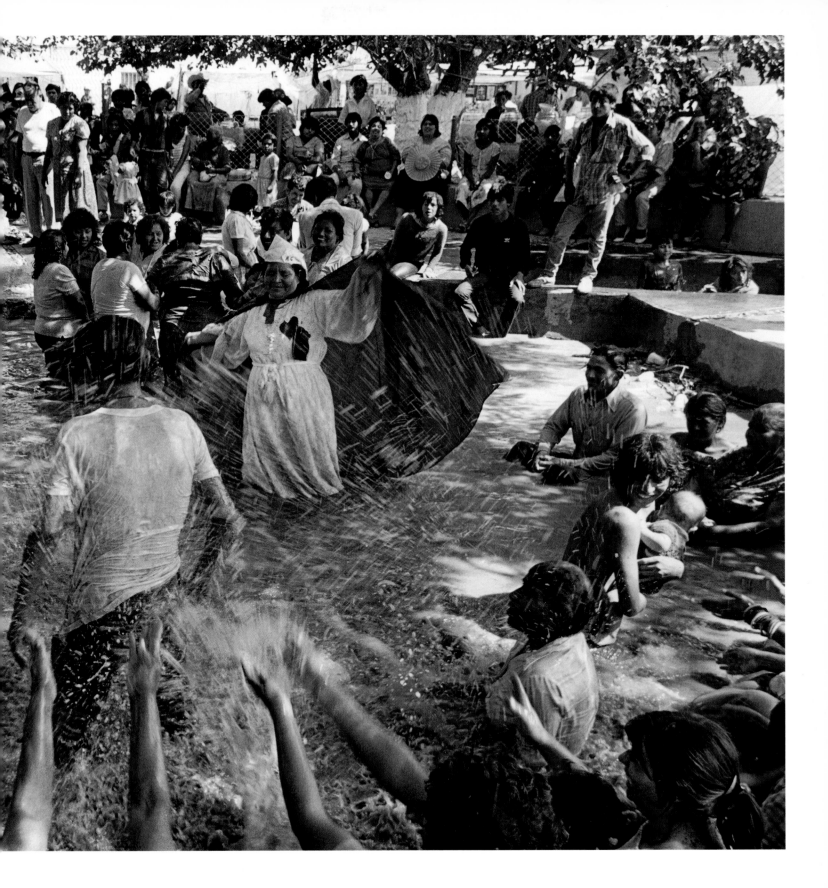

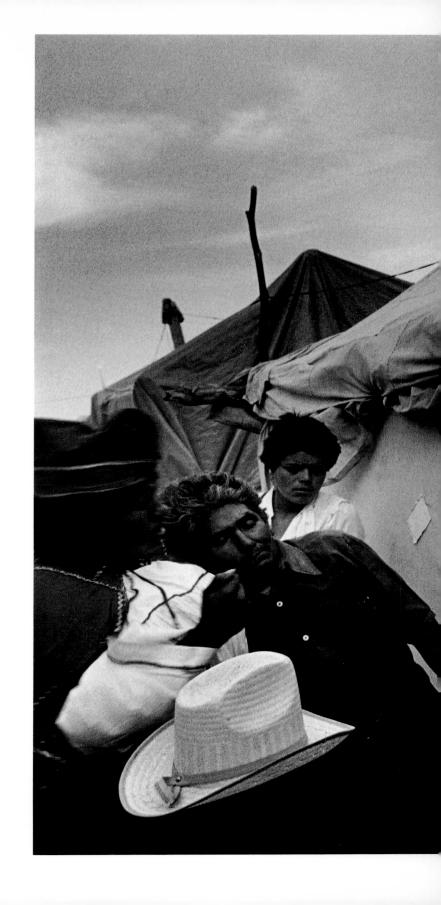

Evoking the spirit of Niño. Espinazo, Nuevo León, 1987.

40

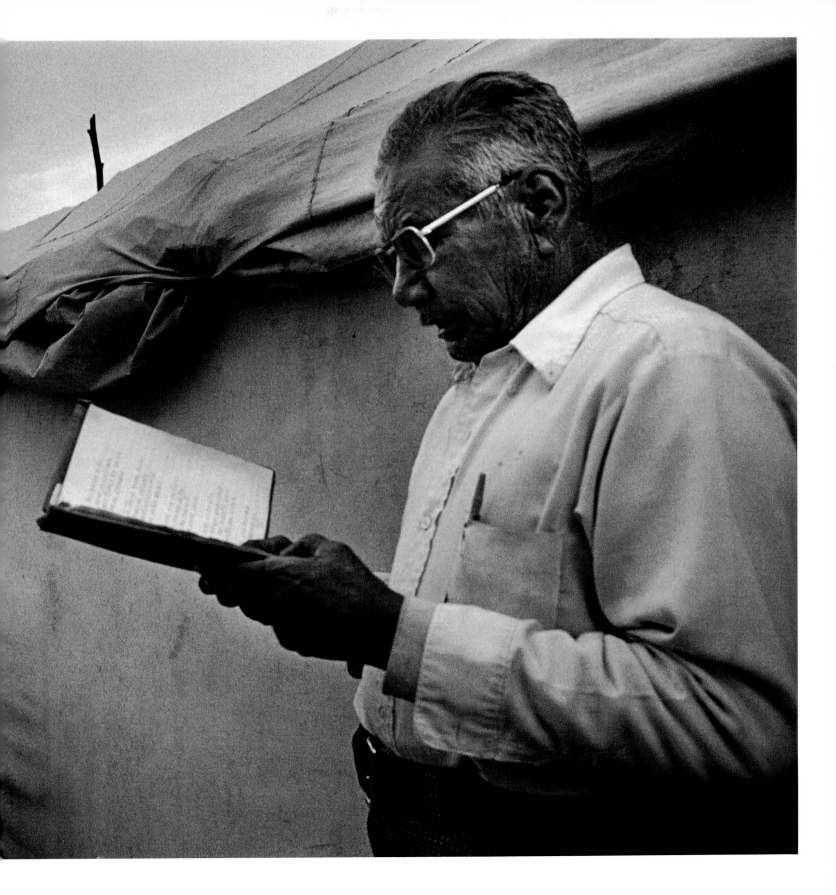

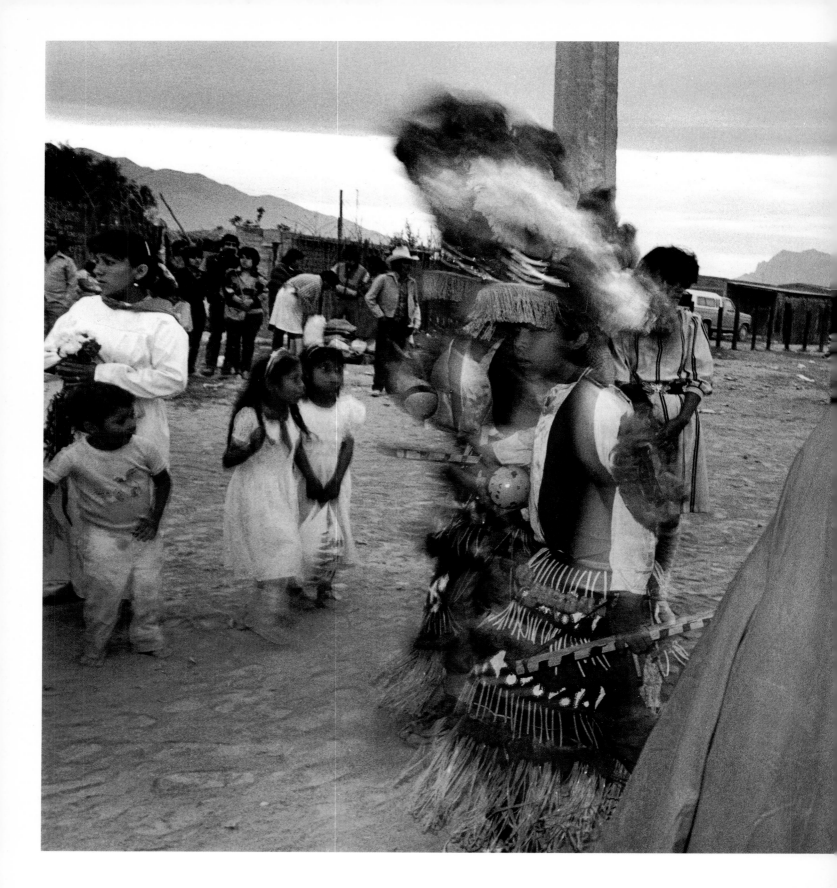

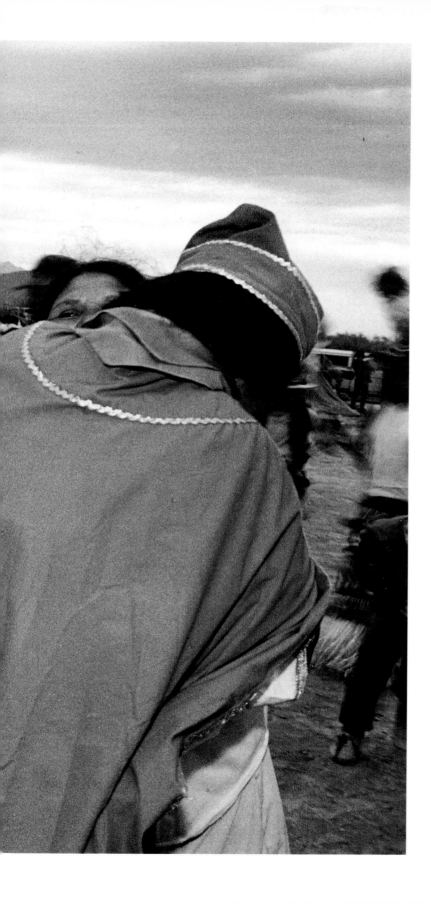

Materia and *Matachine* dancers. Espinazo, Nuevo
León, 1987.

Leo Carrillo, Professor, Corpus Christi, Texas

Theodore Von Bernich, a scholar and spiritual healer from the San Antonio area, was a friend of don Enrique López de la Fuente in Espinazo. They say Von Bernich taught Niño about many medicinal plants and curing potions.

The circumstances surrounding the Niño's death are unclear. The most popular legend is that Niño was murdered by jealous doctors while he was in a three-day trance. A book by Manuel Teran Lira sold in Espinazo says that Niño predicted his own death before going into the trance.

Realize this is a real live form of tradition. What is important is their fascination for Niño Fidencio. Everybody feels that they have a little bit of information that makes their information special. They are not lying to you or inventing information. All agree that he was a very holy man. Other things are going to vary. When did he live? When was he born? What's going on is a process of mythification, a very human process, to try to make your heroes even more heroic to fit the pattern of a hero. March is the celebration of his feast day of St. Joseph. His death in the fall is very appropriate.

Espinazo has a lot of things converging here. It gets its name from the mountain range that begins here. Two states come together here. It is an unlikely place to get to. The more difficult and far out of the way the place is, [the more] the people see themselves as being tested for their faith—not that they are welcoming the discomfort and the hardship, but they realize that it is not too much to ask of them to come so far out of the way and to be this uncomfortable. During the gatherings, they never put enough passenger cars on the train. People get stuck for days trying to get here. They don't complain. They just feel it is part of getting to Espinazo, one more hurdle, one more way to show their belief in the Niño.

Here everybody agrees. It is not so much what they say because what they say is contradictory. It is how they live their lives. They are all aware of the contradictions. The beauty is that it reinforces the fact that they are always talking about the Niño, always teaching each other about the Niño. I am not concerned about the contradictions; it is the mythification process. It is the truth being converted to a higher truth. Contradictions are always coming up over penitencia, *reasons for doing certain* penitencia. *During* penitencia, *a person feels a certain sense of sacredness, that the Niño has stood by them all along. They have to feel worthy of his friendship.*

Then the other level is the promise. They have gone into a little bargaining pact with the Niño. If you help me out of this problem with my mother, out of this or something, I will do this for you. It becomes a form of presentation, paying back their promises. If the Niño has been very good to them, if they accumulated wealth, accumulated a big mission, then they demonstrate that in a form of cuadro *[formation] presentation, dressing their queens and kings very elaborately. All on that road of* penitencia *they show off their pain, their discomfort.*

Niño has his own trademarks. His message is very clear: friendship, peace, love.

Espinazo certainly is very colorful, and there is a tolerance for people taking on spirits other than Niño Fidencio. No one would run them off. He still has several relatives around.

You and I are coming from a Western mind [on the question of whether some materias *seem more genuine than others]; it is the furthest thing from their minds. The biggest test that I see is: What are the people thinking? The people know what they are looking for. The followers are growing in number.*

Materia Emma Gonzáles, San Antonio, Texas

First time I came to Espinazo in 1959, I think. Now I work as a materia. When I see somebody who really needs help, I pray for them. Niño comes to me to help other people. I say words—I don't know where the words come from. I even get surprised at myself: Why did I say that?

I have helped a lot of people. I have helped many in California and Chicago, Illinois. They call me to make a prayer. Then they call me back, "Niñita, it worked." In North Dakota, a little boy was dying. They called me—I didn't know the people. You touch his head, put your hand on the head, say "Niño Fidencio" three times. They call: "I did what you tell me. Boy doing good. I didn't have to see a doctor." It's the faith.

I had to talk to a priest, because my family didn't believe in me working the Niñito. I didn't know if I was doing the right thing. He said, "If you are doing it with all your heart and all your faith, you doing the right thing." Things just came out of my mouth. It was pretty hard at my start. You need the light of God. Everybody has the light of God in their heart. Let the light guide you, then you know where you are going and you are not in the dark. I leave it all to God.

My mother and father and everyone at home didn't believe Niñito could help people. Just God and Jesus. But one time, my mother was very sick. Doctors told us she would not make it through the day—she was going to die. One of my brother-in-laws comes and says, "Why don't you pray like you do to the Niñito and ask to save her?" I knelt down and go to my mother's head and start praying. Niñito told me I was going to have to make a penitencia, thirty-three rounds. He was going to take my mother in a trance and cure her. We had a big yard. No grass or nothing. We just had gravel on it. I kneeled down and

prayed. My husband by my side with me crawling. We went [crawled] around the house thirty-three rounds. My family thought I was crazy. I didn't pay any attention to them—just did what the Niñito told me to do, my husband by my side praying with me. And I saved her. If you don't do a sacrifice, you don't get nothing. My mother opened her eyes. She had never been to Mexico, but this is where she said she went. She starts describing. She saw a lot of little trees and saw the road and saw the tomb. She had never been there [Espinazo]. She got well. She was so healthy from that time till she died at eighty-seven. He has gave us a lot of proofs.

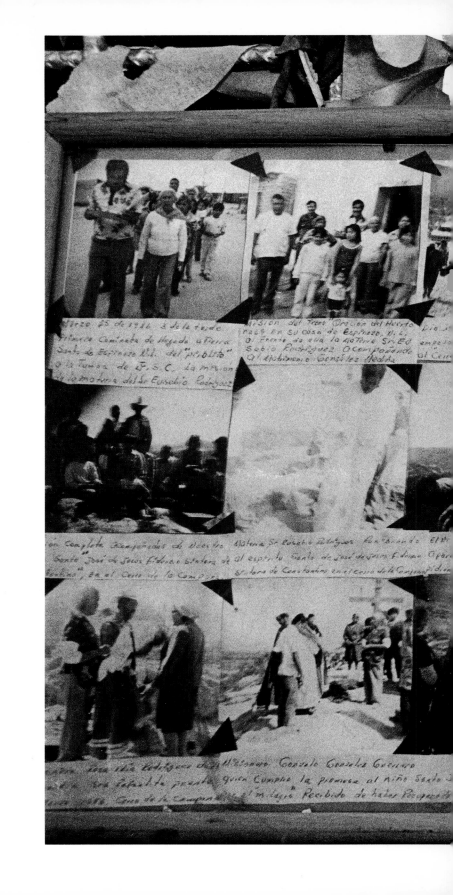

Ex-voto. Espinazo, Nuevo León, 1987.

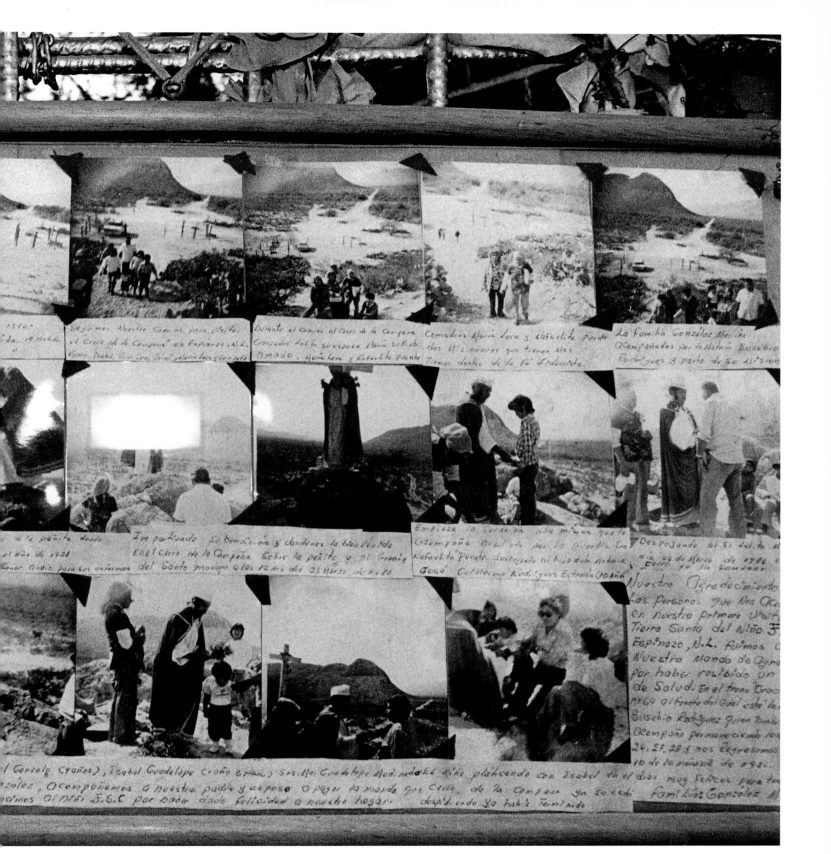

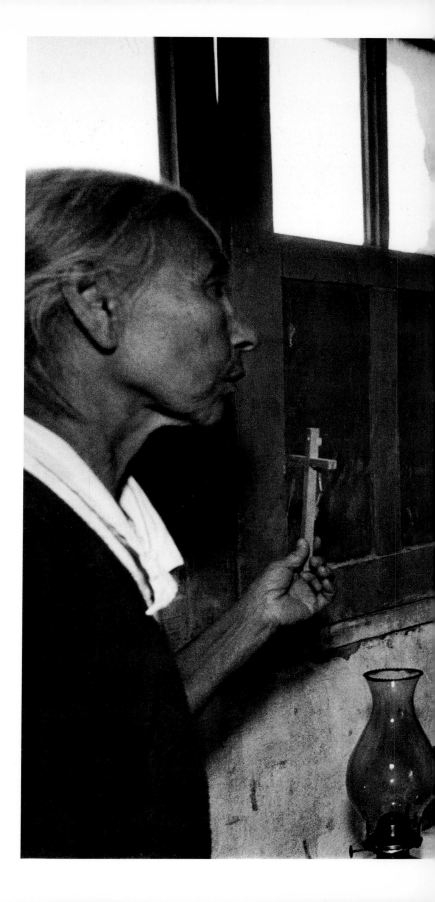

Pepino Sintora Constantino, Espinazo, México

The Niño Fidencio was sick before he died, but he kept working for the people. The doctors didn't like him because the doctors were jealous of him. All the people start coming to the Niño instead of the doctors. So when the Niño got sick, no one helped him. When he died, a doctor killed him—two doctors killed him. The doctors acted like they were helping him, [but] they weren't. One doctor he was from Monclova and the other was from Monterrey. I was fifteen or twenty years old when the Niño died. I was by myself, the oldest of my family. They were cleaning him up with cotton. They sold most of the jars from the tumba [tomb where Niño is buried], sold his blood coming out. Here is a jar. It is the palate of Niño Fidencio and it had a cross up here. People use to take impressions of it with wax.

This interview was in October 1988. Pepino died the next month. He was a relative of the Niño.

La Reliquia, the palate of Niño Fidencio. Espinazo, Nuevo León, 1988.

48

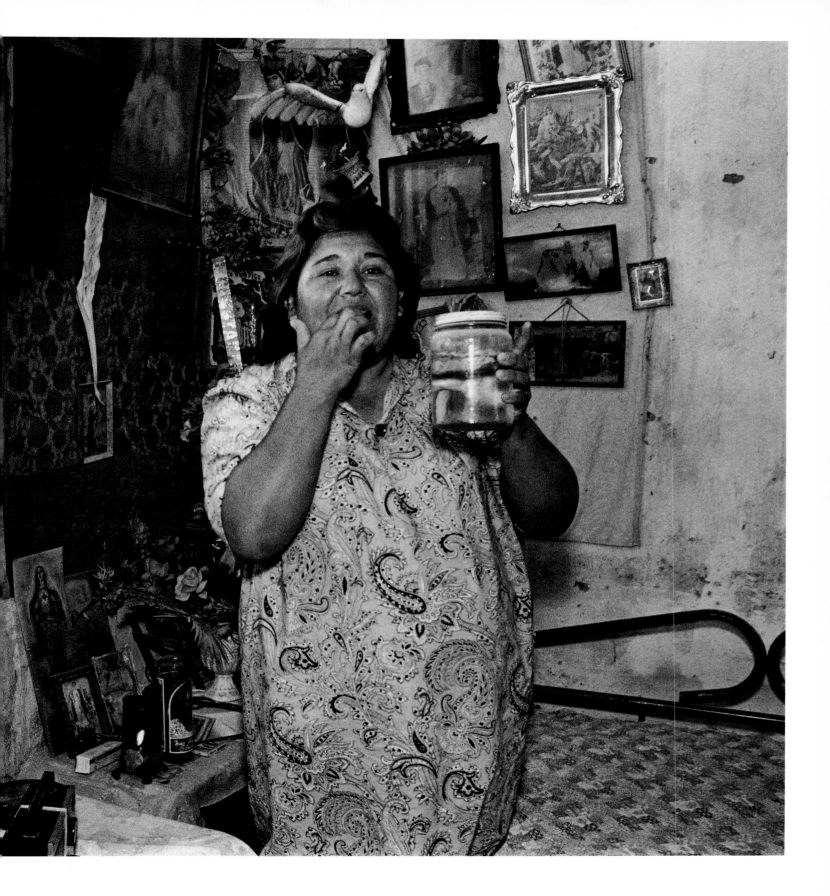

Mary Ramón, Dallas, Texas

A lady friend of mine took me to a good materia *in Dallas. You can feel the presence of the Niño when you talk to him. I have this dead arm—no feeling. "You must go to Espinazo," the* materia *said. The first time I was under the* pirulito *tree was 1965. The* materia *raised up my arm towards the* pirulito. *I could feel a cold piece of ice like running down my arm.*

I have breast cancer. Niño told me he would put all the cancer in one breast and the doctors were going to take it, but I wouldn't have to have no therapy. This was true, and the cancer hasn't come back. Two-and-a-half years ago they take my breast. You think I am not going to be thankful for all he has done for me?

My daughter was ten years old when I was going to him for my breast. The materia *was planning to move to Laredo, Texas. "We need you here. We need you here," I tell. I talk to Niño. He says, "You are going to have me here at your house. What are you going to do with me in your house?" We poor people can't afford a doctor, they are so high. My* materia *is leaving. "I can't let you go, you are my only doctor." He says again, "You are going to have me at your house.'*

The day he took my daughter it scared me. I had been in hospital in a car accident with a whiplash. I came home after eleven days. They sent me home the day my daughter got home from Espinazo. All my kids come over. I forgot to get my pain pills. I told my daughter after all the kids left, "Please," I say, "get me some aspirin till morning when we can get to the drugstore." She got up and get me aspirin and Niño's oil from Espinazo. She said she would rub my back. "You rub me good. I got great bumps on my back. You rub me good." All my muscles, they feel

tangled together. I felt her hands like they were Niño's hands. She was only a child.

That night she was rubbing me, she kept me up till four in the morning. She began to speak about herbs and medicines, and I knew it wasn't her because she couldn't speak Spanish and she was letting words out in Spanish. She was speaking from the Niño. I took her to my materia *the next morning. The Niño said, "Didn't the chickens get scared last night?" He knew he had been there. "Niño, you didn't tell me you were going to take my daughter for a* materia." *He said, "I never ask for what is mine." My daughter has given herself over to the Niño Fidencio.*

There is this old lady in our mission. We put this old lady in front of Niño. "You have to help her with her eyesight," we said. He gave her those spiritual shots. "Oh my lord, I can see," she cried. "I feel like a whole ton of leaves fell over me. Dear Lord, I can see. Take me to him because I can see."

That's just something he did so people who are saying things know that he is a healer. I swear she was born blind.

This interview was made in October 1988. In the summer of 1989, Mary called to tell me the good news, the Niño had come to her and asked her to work for him. She is now a *materia* in the Dallas area.

Reverend Alberto Salinas, Jr., Pastor, Primera Iglesia del Espíritu Santo, Edinburg, Texas

You see when the spirit of the Niño enters a person's body. The face changes, the muscles, they relax, and the eyes roll up. The voice, it changes like a child's. Niño he liked to have fun and play. They said he danced with the people to cure them. He gave parties for his patients prescribing herb baths, laughter, and foods. He was so good. He

*was so kind. Everyone loves the Niño. The reason the
materias take the people to el pirulito is the presence of
Niño is very powerful there. You know God sent Niño
to Espinazo because there are many medicinal plants and
herbs in this area. When Niño died, his followers let him
lay for days hoping he was only in a trance and would
come back to life. After a few days, doctors were called in
and slit his throat for autopsy.*

*The salon where Niño is buried used to be a hospital.
On the second floor was a maternity ward and he also
cared for about twenty-six hydrocephalic children. There
also was a cancer ward. You understand, of course, that
even in Niño's time it was illegal to do what he did, per-
forming operations with a sharp piece of glass. The
doctors began to suffer in the area. The doctors wanted to
get rid of him. Doctors would hire assassins, but Niño
could always pick them out of the crowds of thousands
and make them surrender their guns or poisons. Now there
are possibly a million followers.*

Reverend Salinas is a cajón in Edinburg, Texas.

Alma Martínez, Castorville, Texas

*When we first got to Francisca's house, we stopped on the
side of the street and I knocked on the door. It took some
time to hear because they had a loud radio on. She came
to the door, and I told her my name was Alma Martínez
and I was here because this girl, Dore, wanted to talk to
her. She said, "Oh, I know that because the Niño told me
you were coming." Niño lets her know things ahead of
time and that he is psychic he makes her psychic in her
material life, not only when Niño's spirit is around her but
even when he is not in her body, she knows in her mind.
That is how she knew we were coming—he lets her know.*

"I know everything you are coming here for, and I am

*ready for you. You are welcome to come into my house."
She went in the back to her* tronito [little throne, altar to
Niño Fidencio] *and she had her testimony ready on
how she came to work for the Niño and started giving us
her testimony before we even asked.*

Materia Francisca Monsivaíz Aguirre (Panchita), Misión Fidencista Jesús Sacramentado, San Antonio, Texas

*I am seventy years old and have been a materia for forty-
seven years. When I first went to Niño, I examined my
heart. When I first met Niñito, I was a person who didn't
believe in anything. That is when I took my son, Ricardo
Muzquiz. I turned myself to Niñito because of my son.
Through love, everything is possible.*

When I walked in the door of the tronito, *the first thing
I saw was the cross in the room with the Jesus hung. I had
offended him by not believing in anything. I asked God
in my heart if I was worthy of my son being saved, and if
not, I understood he would have to die. My son had no
movement, no motion of arms, eyes, legs, anything.
I didn't know if my son suffered or not because he had no
way of telling me. He wouldn't talk or cry. He was like a
rag doll. In Rosita two weeks earlier, they told me there
was nothing that could heal my son.*

My son had a contagious disease, parálisis infantil
[infantile paralysis]. *My son was like a rag doll three
months and three weeks. I went to the doctor that day.
They told me he would die by four o'clock in the evening.
I walked out in a daze. I was crying and asking God,
"Please don't take my child away."*

*When I was wandering in a daze on the street, my
father-in-law found me and asked me, "What is wrong?"*

"They just told me my son isn't going to live past four

o'clock this afternoon." My father-in-law said, "Come on, let's go." My husband came by to pick me up at my father-in-law's house. The doctor reported me because my son had a contagious disease. The doctors had sent soldiers to quarantine the house when we got back to Monclova. The soldiers were keeping everyone out of the house. Me and my mother had my son in the crib.

At night the doctors came to take my son away. I told them if you take my son, you are taking me too. I grabbed on to the crib and didn't let them take him. The reason they didn't fight me was that I was pregnant. They said they would return with higher enforcements. I ran out of the house and hid in a ditch over a creek bed. They came again at twelve o'clock. I spent the whole night there. I kept my son to my bosom to keep him quiet so no one would know I was there. I put a whole bunch of dry leaves and made a bed and I held my baby close to me till morning.

I went to this old lady's house. Her name was Tomasita. Tomasita told me on Juarez Street in Monclova there is a Niño Fidencio materia, healing people in the hacienda. He is doing a lot of healing. Tomasita says, "He has healed me of my strokes, epilepsy seizures." I know if they take my child now they will never bring him back. Tomasita says, "Let's go there."

That was the first time I entered a Fidencio templo. When Niñito saw me he said, "Please do not cry anymore." He told me, "You are more dead than the child you carry in your arms. Give him to God. Turn him over to the eternal Father." Niñito asked me for helping me, what would I give him of my life. "What would you give me if God would grant you balsamo espíritu [spiritual healing] and the permission to come and manifest in your son? What would you give me for giving the life back to your son?"

"If you see anything that I have, anything, ask it of me and I will give it to you, anything I have of mine."

Niño said, "You have a lot to give. Your heart is bigger than your body, and those kinds of hearts I am looking for so that my heart can come into all those hearts that suffer like you. The heart of a mother living through so much pain."

"Please heal my son," I cry. "That is what I have come here for."

Niñito talks back and tells me, "I hope God will grant me this santo bendición [holy blessing] so he will manifest himself in your heart, and so that he will grant me permission for my heart to come into your heart so I can form myself in your heart like a glass with a cross inside of it picked out. So that I can continue my charity in your heart."

Then the Niñito turns to the two hundred people at the mission and says, "This is a mother giving up her son. This woman has given her heart to me. Pray that her son gets well."

Niñito smiles at me and tells me, "Do you know what you are saying, woman?" I said, "Yes, sir, I know what I am saying. I want you to heal my son."

He put my hand above my head and hit me three times on my heart. In front of all the people, he said, "Listen to what I am going to tell this lady." All two hundred people were witness. "Pray that her son gets well because she will become one of the hearts that will serve me, my servant, for many years to come." I gave myself to God.

Niñito turns to the people and says, "I am giving my heart to God. Listen well to what you are saying and what you are doing on this earth. I come to look for hearts. Remember like the saying goes, it is like you are getting married and don't be like the married girl who cries she is married after she gets married. You are giving yourself to God. You are an ignorant mother who is giving yourself up for your son. Listen to exactly the words I tell you because a ray of light will spread itself over you, over your heart,

because God will be right in your heart and listen to what I am going to give you, the recipe that God has given me. God has ordered. You are going to get a cup of water and a cotton and a spoon and you are going to spoon the water onto the cotton in your son's mouth. If your son passes the water, he will get well. If he passes the water, you should be proud and honored. Your son had an attack. The doctors didn't notice. The muscles in his throat are stuck."

I did this to my son all night long, till morning, and my son started trembling and shaking. I screamed, "Niño Fidencio and that ugly man have killed my son!" Because I had no faith and I was ignorant, I did not understand the faith of God. To my surprise, Niño Fidencio was standing at the door. Niñito was in that man's spirit, but he was incommunicado. He had a whole lot of people sing the songs to Niñito. I was cussing: "What a terrible uneducated man he is, what a cruel man." But he gave doctrina [doctrine] to me. He was preaching and defining to me. Now I follow his road.

Niño says, "Please be quiet. Don't condemn me. How much more can you damn me?" I am quiet then, and Niño takes out a bottle of oil. He took the oil and rubbed it on my son, and to my surprise he started moving his feet. He started wiggling his feet.

Niñito started throwing out this bag of fruit from my son. The body has made a bag of the bad fruit. He isolated the poison from the fruit my family had given. That fruit had a bad life. My mother-in-law, she didn't like me. She sent a basket of poison fruit. Somehow my son ate it, and that's why he got paralysis, that fruit was poison. Niño healed him, and I felt a great sympathy from me, so big.

My son was still dead from the waist down. My son had life only from the waist up, and he would drag around with his body. [Again] on the 24 of December, I took my son to Niñito. You have to come wrap up all the Christmas presents, and to my surprise, I knew what was in the packages, and Niñito didn't even give me one candy or nothing. No gifts for me.

The Niñito told everyone pick up your gifts, and I felt very bad. I didn't have a gift to pick up, but all of that was to cleanse my heart and conscience, so Niñito could see if I had any feelings and sentimiento. A cleanliness in my heart and in my conscience. He told me to leave and go to the back of the line. He told all the people that they were going to play a game of ball, but that the ball had eyes, feet, legs, ears, hands, and arms, and that it has life, and that I am the owner of the ball, and they would never give the ball to me. Niño said, "Don't give it to her," and I was crying because I was afraid they would drop my son. [The ball was her son.] He went around three times, playing ball, hand in hand. Niño asked for a cotton diaper, and they wrapped it very tight around my son's waist. He stood him up and pushed the baby. He made a trick with the way he wrapped the diaper. He pushed him out, and the baby started running towards me. He ran to the door where I was standing. My son ran to the door and hugged me, and he walked.

That's the miracle, and that's why I am a materia for Niño. My son is forty-four years old now and has six children.

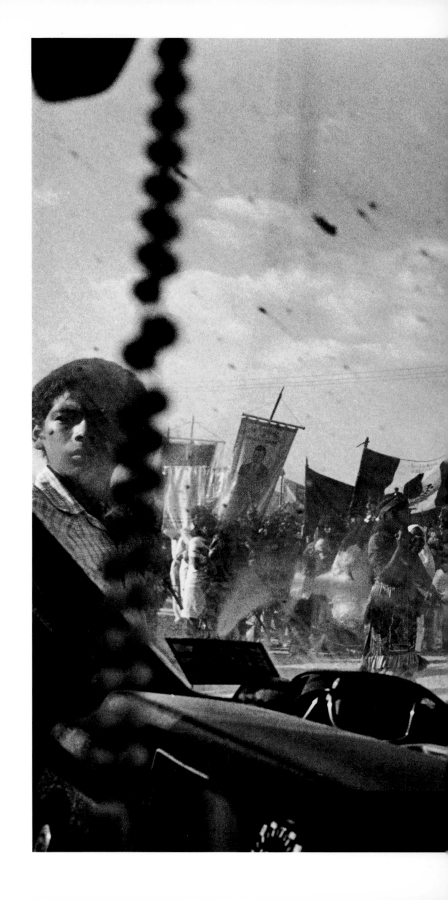

Espinazo, Nuevo León, 1988.

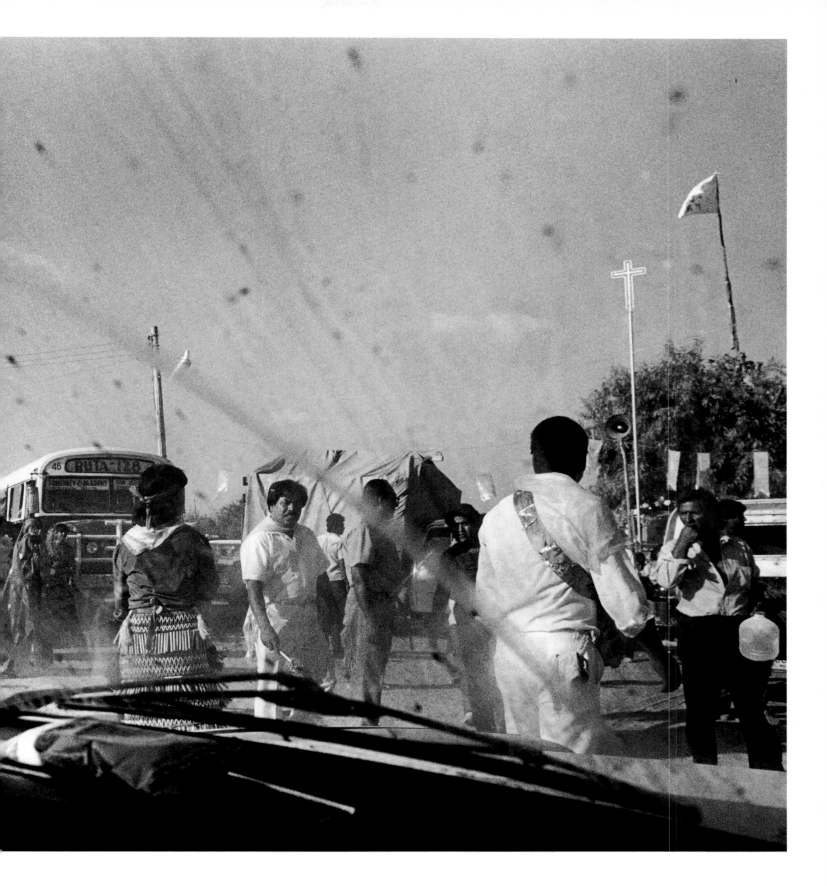

Espinazo, "la tierra santa," 1987.

Toñita Gonzáles. Espinazo, Nuevo León, 1990.

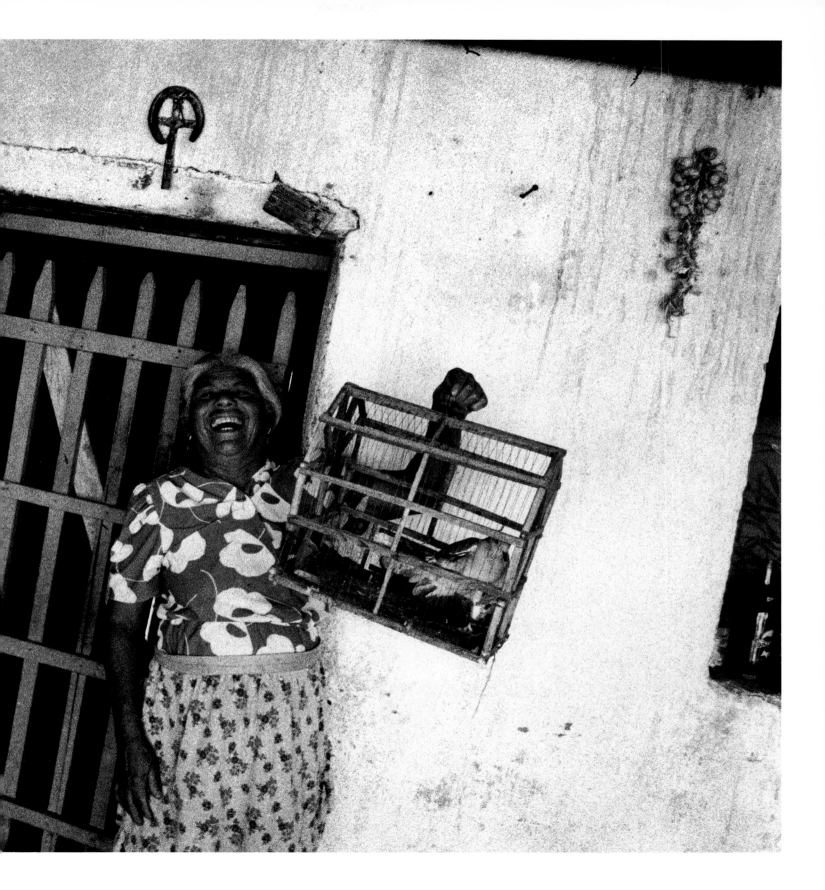

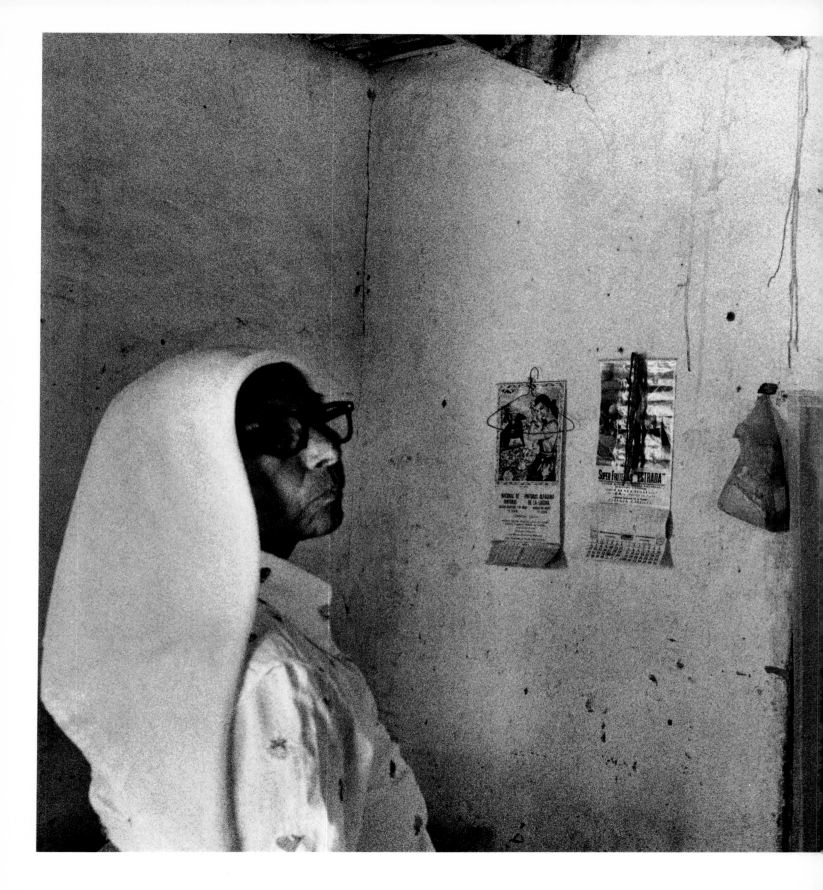

Maximina Constantino. Espinazo, Nuevo León, 1990.

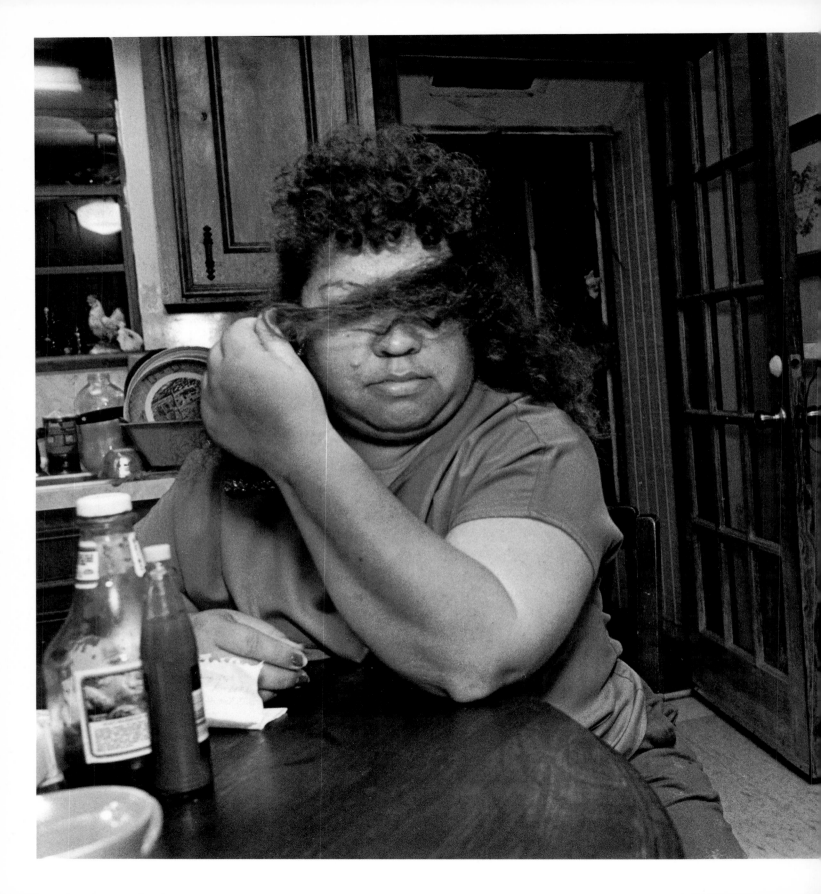

Alma Martínez, Castorville, Texas

When you pass out from when you are with the Niñito, it usually means you are going to be a materia *one day. Feels like you are in a trance, and you feel you know everything. You don't want to wake up from it. Sometimes you see things. Your conscious sees Niñito or Jesus or a virgin, a peaceful woman in blue. I figure it is somebody. When my dog died, there was a man on the side of me in a beautiful white robe running around with my dog. I knew its spirit was somewhere with God. It's vivid, but it's not material. It's like ESP sense.*

Alma Martínez. Castorville, Texas, 1991.

Materia Elodia Jiménez, Lytle, Texas

I start praying and I pray and I pray. It takes me fourteen years for Niño to come into me. I remember one time, once, I was praying the rosary. I'll never forget this. I finish praying the rosary, then I feel something heavy, you know, that come to me, real heavy, and I say, "If you are the spirit of Niñito, it's okay, but I want no other spirit." But just in my mind the first time. I can't talk. I feel something heavy.

And then, the second time, I told my family the Niñito was going to come. I was in Houston. I go to visit relatives. I was over there, my cousin was there—she believes a lot in Niñito—so we were talking in the kitchen about Niñito, and then I feel my eyes were closing, getting little and little. I told my daughter Alma, because she was there, I think Niñito's here. You know, my eyes keep on closing. Then I feel that weight, the weight that Niñito said he was there the first time. I was not scared. He kept coming to me and coming to me. I have him coming for seven years now. It was the 20 of August. I remember well.

I use to receive him in my front house in the living room, and then last August he fixed me this room over there where people can sit. I have three rooms over here for the Niñito to come. Whenever I feel strong, then Niñito is going to come down, and then I start praying the rosary, and he just comes to me again. I use to go to a mission in San Antonio, but now the Niño he comes here.

When I started getting near the Niñito, he take away a lot of suffering from me because I'm a person who suffer a lot since I was a little girl. I make, how you say, penitencia whenever I go for the Niñito. I never look for a chair to sit down because I know he start taking me away from all the suffering, and he make me feel good.

Fabiola López de la Fuente, President of the Society of Fidencio Sintora Constantino, Monterrey, México

It is not that he was really born on October 17, but it is when at el pirulito he received his healing gift from God. He was reborn. Niño even predicted his death, and he told us he would be back, and that hundreds of people would claim to be him. Some, he said, would be him, but others would be false. Niño said, "Materias are like the stars in the sky: Some shine brighter than others." The materias are not curanderos like Niño was. A curandero has the power of healing and a materia can only do healings when the spirit of Niño is within her.

We formed the society about eleven years ago in an effort to distinguish between the true Fidencista and the false. He was more than just a curandero but a doctor and midwife and dentist to the people, and my father use to say he was able to diagnose the people—just by looking at them he could tell you what was wrong. He cured not only the poor but middle-class and rich people from well-known families—politicans and generals. He cured caravans of sick. But he was a simple man. He never kept even the things that were given him and would throw it all out to the crowds from the roof—money, fruits, foods, jewelry, anything.

Alma Martínez, Castorville, Texas

You are suppose to say as you leave Espinazo, "Good-bye, tierra santa [holy land]. See you later, tierra santa." Niño Fidencio always said you are in holy land in Espinazo, in el campo del dolor [the land of pain].

When we went to visit don Alejandro—for he knows many things, like the way things were when Niño lived—

a cool breeze came into the house. Both of us were talking. Our thoughts were the same, we were in such communication. It was so peaceful. It is like being asleep with your eyes open. There was this rattling noise, it was nothing.

Don Alejandro, Espinazo, México

I feel like I am Niño Fidencio's eyes. I think that he was really Jesus that came down, because none of the materias *have healed the way he did or done those kind of operations.*

I don't say nothing about how doctors can heal, but I feel I have never seen nothing like the work Niño Fidencio has done in this world. Before an operation, Niño would break many bottles on the salón *floor, then pick from the broken glass one special piece to do the operation. When I use to be with Niño there was no nights, no days, no time for nothing but to be with him. He would rest by curling up in the corner of the* salón.

Don Alejandro was a young boy when Niño lived and now is known as a very good herbalist in the town.

María de los Angelos Vadillo, Via Frontera, México

Niño always ordered and made sure that the singing and dancing would be going on day and night for the sick because it would make them feel better. They were a part of the world. They weren't isolated from the world even though they were sick.

This family had a problem: one of their childs was sick. They told them the child was not going to get well. They had heard of Niño Fidencio, that a lot of people were coming over there and getting healed. The wife had already given up hope. *The husband kept insisting: let's go see. They decided since they had a car they would drive over as far as they could. On the way over there the car broke down and they were in the middle of nowhere. You look everywhere and there is nothing. There was no water. Suddenly there appeared a boy. The man asked the boy, "Do you know where there is water?"*

The boy said, "Do you have a can or anything I can put it in?"

The man said, "Yes." The boy ran off. He appeared again. He brought water, and they put the water in the car. He was very grateful that the child had brought him the water, and he said, "I have nothing to pay you with so, here, take these rings." He took his rings off his fingers, and the child took the rings. He asked the child, "Where is Espinazo?" The child said, "You are almost there."

They didn't know where the child went. He just disappeared.

Then Niño told the people that helped him there was a man coming with a very sick child, and I want you to let me know when he comes so he can come straight to me. The man came up with the child. The Niño was moving his hands over the child, and the rings were on Niño. At first the man wasn't paying attention because he was healing his son. Then he noticed that those were his rings. "Oh, you were the child that helped us with the water, you, Niño Fidencio."

When we would be with the Niño, we would stay up days. Days and nights were joined. We never go to sleep, and we never felt sleepy. If you came to be healed by the Niño, and he told you to stay three months, you have to stay there, or even six months you have to stay. When we would be making penitencia *from the* pirulito *to the* foro [room where people gather in the salon] *Niño would always say, "Hurry! Come, let's go meet the saints." In the*

early days the people doing penitencia *would adorn their bodies with cactus but you don't see that anymore. When you went to the Niño to be healed, he never looked you straight in the eye. He had a lot of power.*

Richard Zelade, Journalist, Austin, Texas

Most of the time there were twenty thousand people camped out in Espinazo. He definitely was the first mass-media-produced folk saint.

All the time Niño comes along and manifests himself in ways. Awhile ago in Espinazo, a young boy was lost. He wandered around for a day. No one could find him. They found him out there in the desert placed gently in the middle of a big group of cactus, resting. When he was found, everyone asked him how did you get in the center of all these cactus, for it is impossible—you have no marks or scratches or thorns. The young boy said, "A man in a white robe lifted me up and put me there to be safe till I was found." He is definitely a twentieth-century phenomenon.

Niño also did astral projections. He visited other places through yoga and meditation. He always put on shows at night to entertain the thousands that came to Espinazo. Every night there was singing and dancing in the salon. He had a chorus line of singing and dancing girls. In the end of his life, there were lawsuits and negative publicity, and it took its toll. Ten thousand followers declined to the hundreds, but they were the most fanatic. When he died, they regarded him as a supernatural power.

President Calles was on a nationwide tour when he came to Espinazo. He came through to find out what was going on in Espinazo. It was the time of the wars of the Cristero problem: 20,000 to 30,000 good Catholics in Espinazo and many stories he heard. But this Niño Fiden-cio knew a secret of Calles that no one else knew about his daughter, and after that Calles had food and medicines sent to Espinazo and had the train stop there.

Materia Emma Gonzáles, San Antonio, Texas

The materias *were taught* fé, esperanza, caridad *[faith, hope, and charity] till the day they die. The* materias *in Texas always visit missions in Mexico, and the Mexican* materias *always come to the missions to visit here in Texas. Compadre Victor [from Espinazo] come back and forth across the border. He helped in the early years to organize the* materias. *In the U.S., Olga Gonzáles and me were the first* materias *in Texas. We all use to be so united to each other and we use to go from one* tronito *to another. Twenty, thirty, forty cars behind each one going from one place to another and that was every night that compadre Victor was here. We share with everybody we knew. We took him everywhere in our cars, and they would expect him with a lot of food, a big blessing that Niñito would give. Compadre Victor worked with the spirit of Niñito. The spirit came down in him too. He would give us the stories of Niñito. When he was around, stories about what was going to happen and what we were seeing now.*

The road to Espinazo is only seventeen years old. Before we use to get there by truck and machete. When we first began, we would have to go to Espinazo by train; there was no road. We would have to put the bags out the window of the train so we could get off on time, the train would barely stop a long enough time. Next time, I said, I am going to come in my truck. So we all got together. My husband got me some big machetes. This was in 1959. We had several misioneros *with me. We had to chop up the cactus trees so we could get through. That is how we started building roads, like a country road. When someone*

would get stuck, someone would go get somebody, come with the burros to get the trucks out. It took almost a whole day to get from the main road to Espinazo. In the 1960s, we started building places to stay, little houses. Before we would stay outside. People would sell things on the road to the tumba from since . . . I can't remember. I have heard—I don't know how true it is—but this man couldn't get work, so he went and told Niñito that he was out of a job, and he had a family and everything. So Niñito says, "You can work. You start making me out of clay or cement or whatever, and start selling them."

You know I cannot swim, but I saved a drowning child. I am so scared of water, I don't even know how to swim. My children screamed, "My mother don't know how to swim," when they see me. But I swam out and saved the child. But it was not me. It was the spirit of the Niñito. It was when I was with the spirit of Niñito.

What it is like when you go into a trance is that a white light, a white light so strong, comes and you have to close your eyes.

Newspaper Article, Mexico City

A journalist came to Espinazo while Niño Fidencio was still alive but close to death.

The working days of Niño Fidencio lasted from twenty to forty hours, after which he would sleep six or seven hours.

Jacobo Dalevuelta, the most distinguished journalist of this time, wrote, "His appearance is one of a simple, natural young man; that of a pastor of goats, of those that do not know the good from the bad; of those who have lived underneath the rain. When I saw him for the first time, he was extremely pale with deep-set sunken eyes. He constantly would drop his lower lip to the left. His sleeves were rolled up to the elbow—seated, in the circle of healing, surrounded by the sick. Fidencio has the character of a good man. His countenance is that of infinite goodness and of sweetness. He lives like a child, he speaks like a child. His body and his spirit are dedicated to the service of all the sick people. His healing circle produces repulsion; but his self-denial transforms this hellish circle into one that attracts."

The paper also collected this testimony from a priest. "The man cures maladies of the most bitterly infected and cures the people of the most annoying illnesses. He passes out among the sick rare liquids that he extracts from the plants which grow in the region. Fidencio is a humble man. He applies his healing remedies simply, sincerely, without talking about them. He is not looking for money or fame. I have seen him refuse a large sum of money offered by one of his grateful patients. He takes the money he needs to live and to prepare his medicines. That is why Fidencio is famous. I know that many poor people have received help from this extraordinary man. What I know is Fidencio never had any sexual activities, but in no moment did he give indications of female tendencies. His character looked childlike, and he was scared that he would lose his healing powers if he would charge money or live with comforts or experience sexual pleasure."

From an article in Alerta found on the wall of a mission in Lomita, Texas.

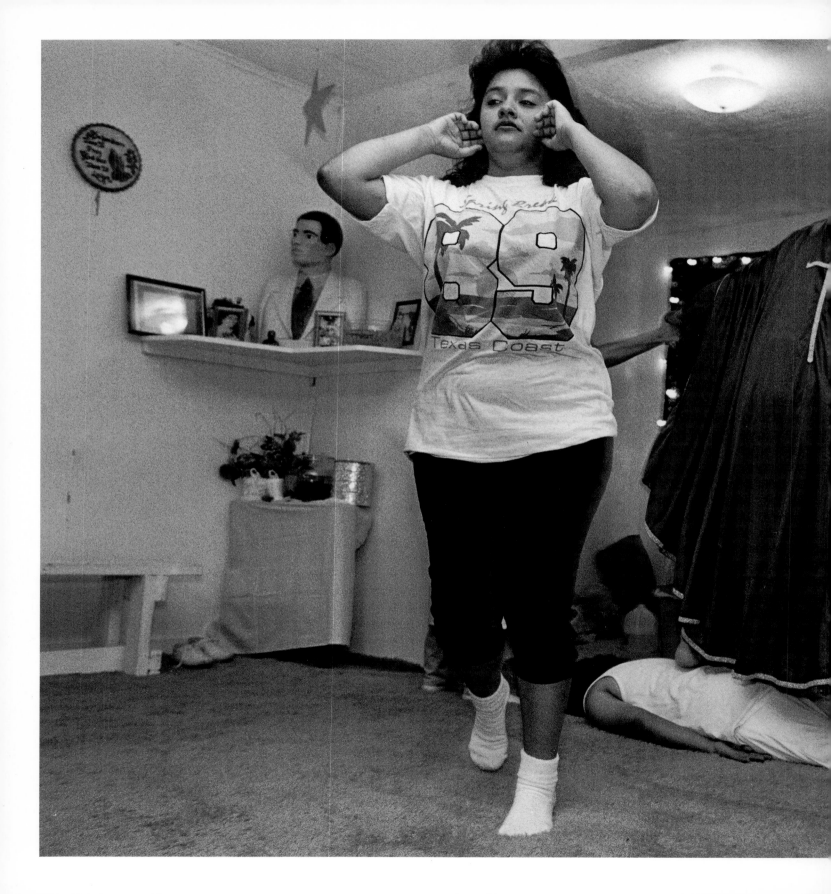

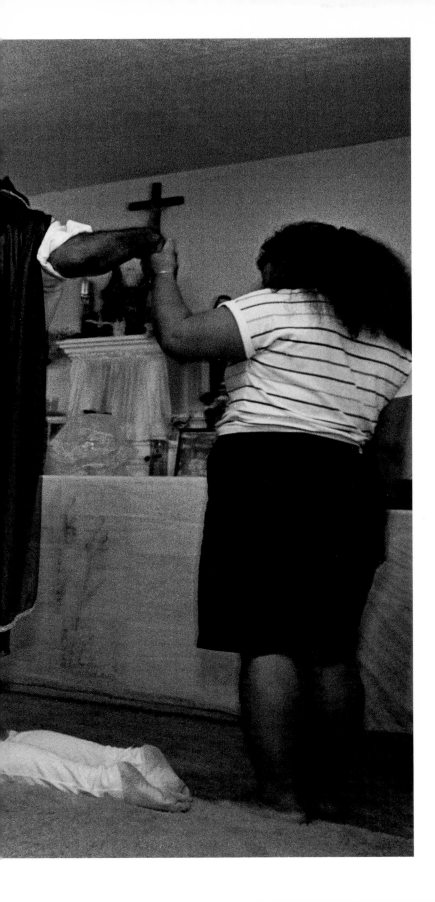

La curación. Niño Fidencio Mission, Natalie, Texas, 1989.

Remedio for a blocked ear. Niño Fidencio Mission,
Natalie, Texas, 1990.

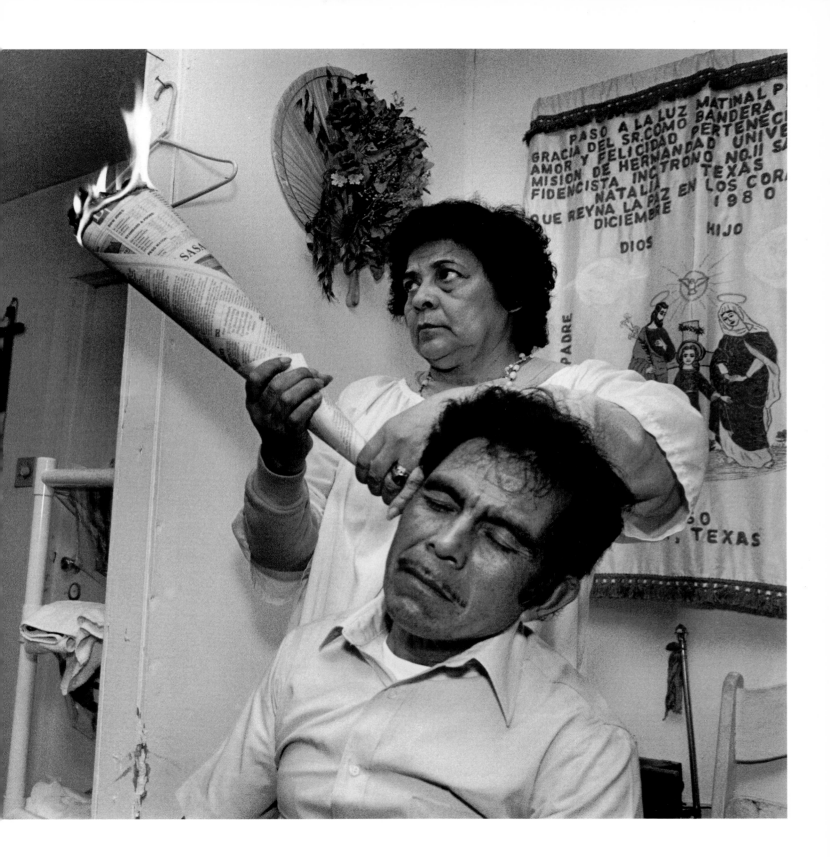

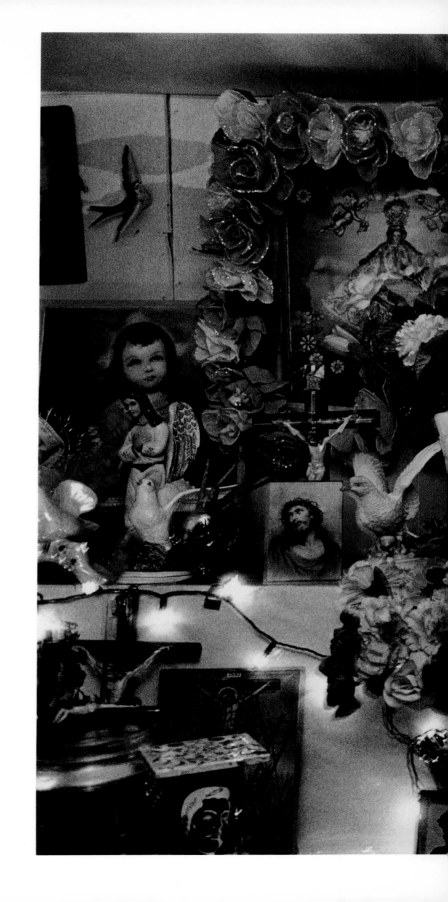

Materia Angela Salazar's *tronito*. Nuevo Laredo, Tamaulipas, 1986.

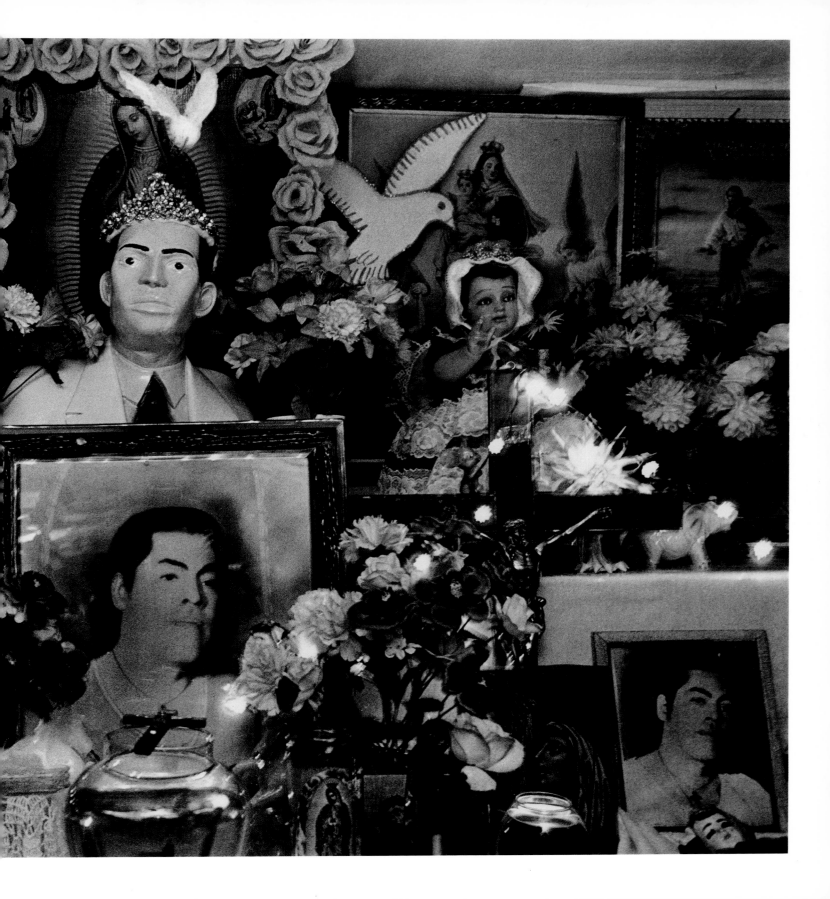

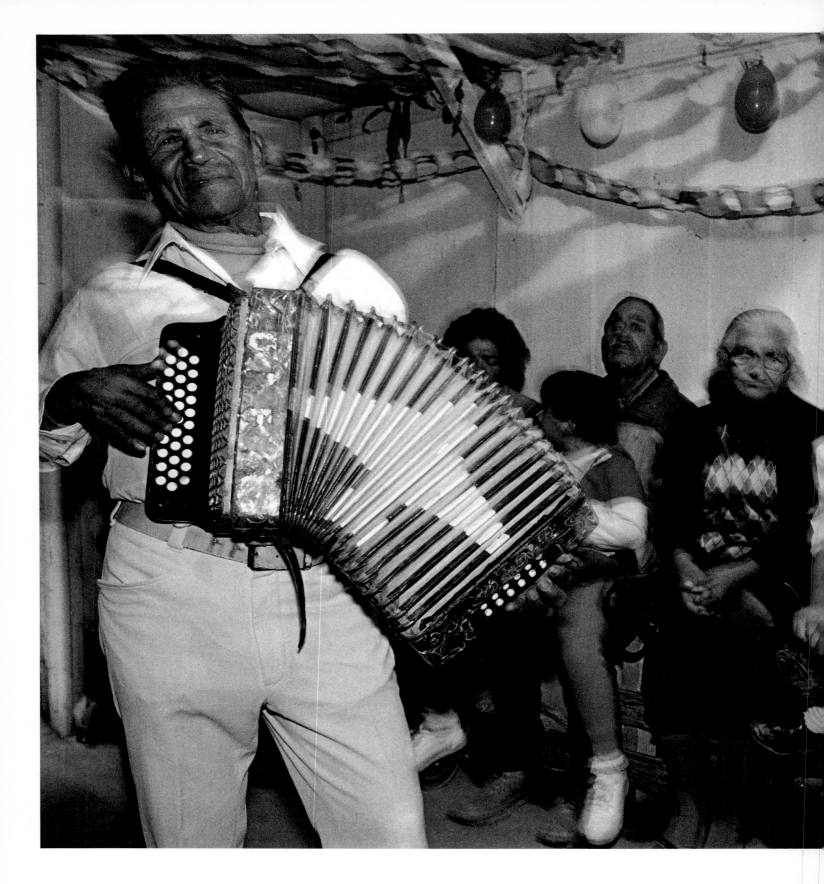

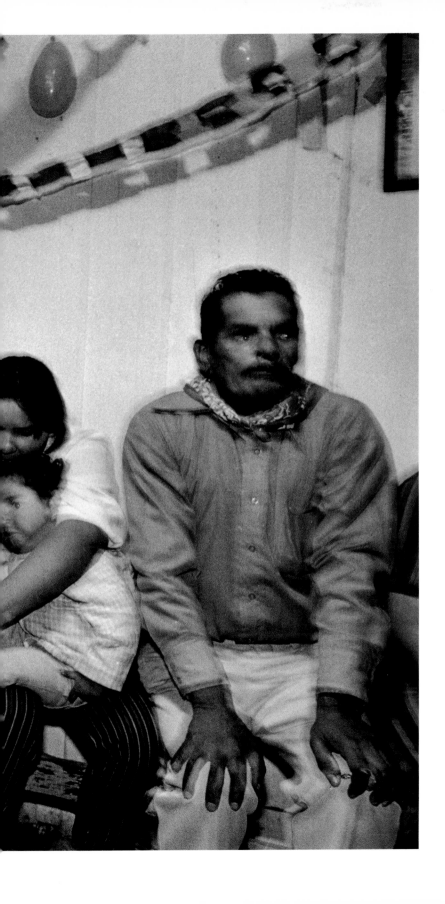

Waiting to see the *materia*. Niño Fidencio Mission, Nuevo Laredo, Tamaulipas, 1986.

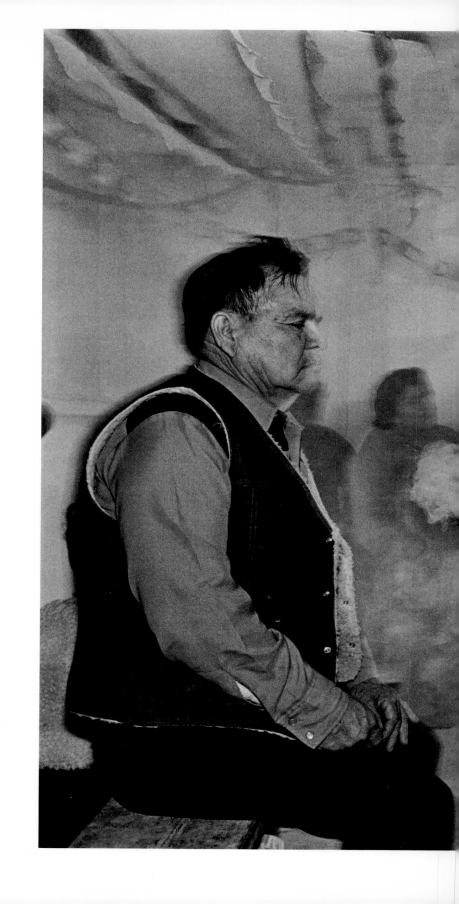

El sahumerio (purifying the room). Niño Fidencio
Mission, Nuevo Laredo, Tamaulipas, 1986.

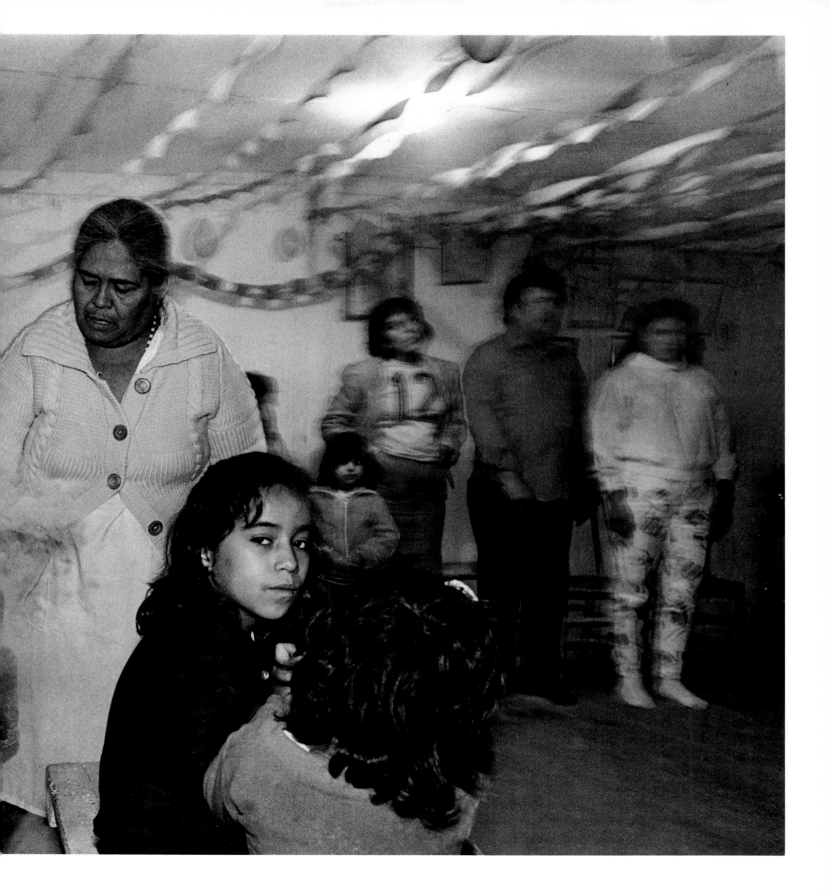

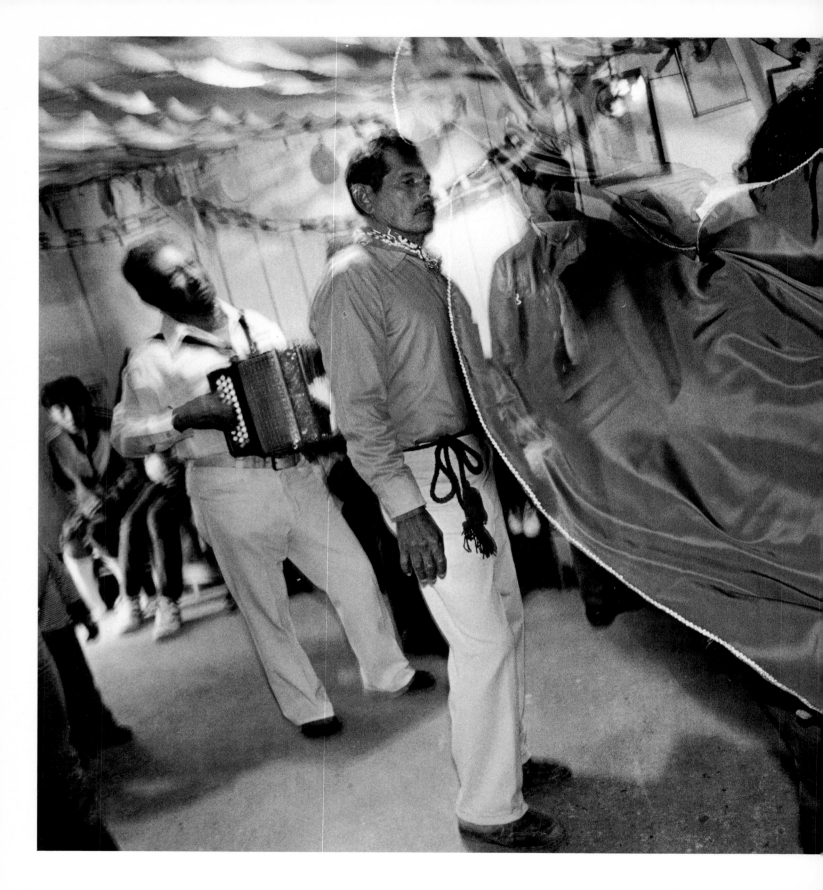

Materia Angela Salazar, *curación*. Niño Fidencio
Mission, Nuevo Laredo, Tamaulipas, 1986.

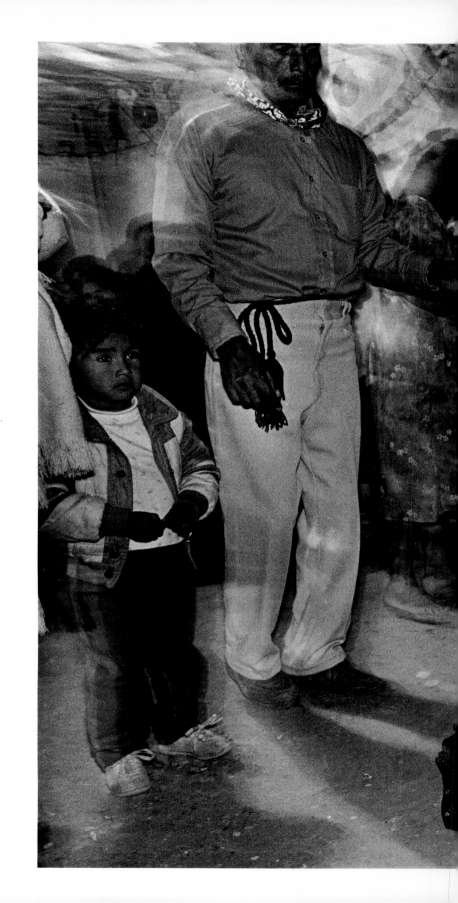

La curación. Ninõ Fidencio Mission, Nuevo Laredo,
Tamaulipas, 1986.

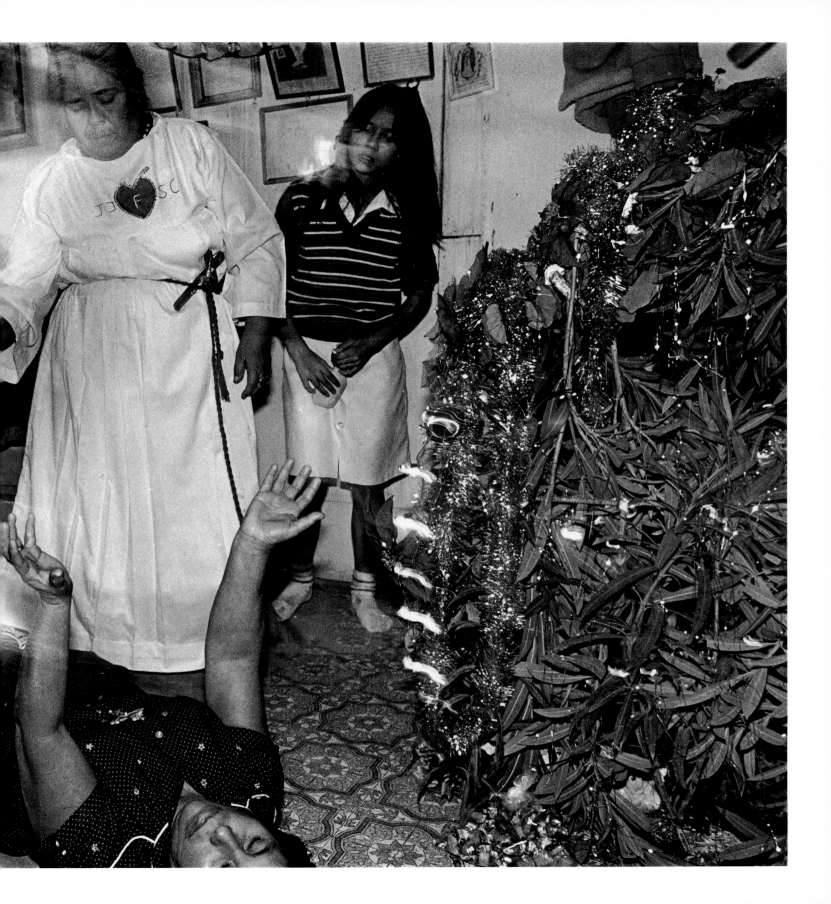

Materia Francisca Monsivaíz Aguirre (Panchita), Misión Fidencista Jesús Sacramentado, San Antonio, Texas

Two times I had a dream recently that my body was over there with Niñito. You know he tells materias *when they will die. I think he is getting me ready. My spirit is beginning to go up an elevation closer to God's.*

Let me tell you the preparation of a materia, *what has to be. Niñito is a doctor, a lawyer, a father, a protector of blessing. He is medicine. He is nothing but for natural. When the sick come to the* materia, *she has got to be prepared because Niñito will be all these things to the person who comes. Niñito is a simple man, a father of herbal medicine. As a* materia *myself, whenever or wherever they call me, I am there. I go to the hospitals whenever they want Niño Fidencio. I will go, homes, businesses. Niño is also a speaker. He says, "I am the* peregrino misionero *[missionary pilgrim] in your heart," because he sends me everywhere. He is always with us. Niño never distinguishes anyone. Everyone is welcome. He is a savior of souls. There is no way you can be a* materia *because you want to be. Niño is the only one to choose you, if you are destined from God. That is the way it is. I don't care if you jump, holler, or scream. Niño is looking for good, strong hearts.*

Materia Francisca Monsivaíz Aguirre (Panchita). San Antonio, Texas, 1990.

82

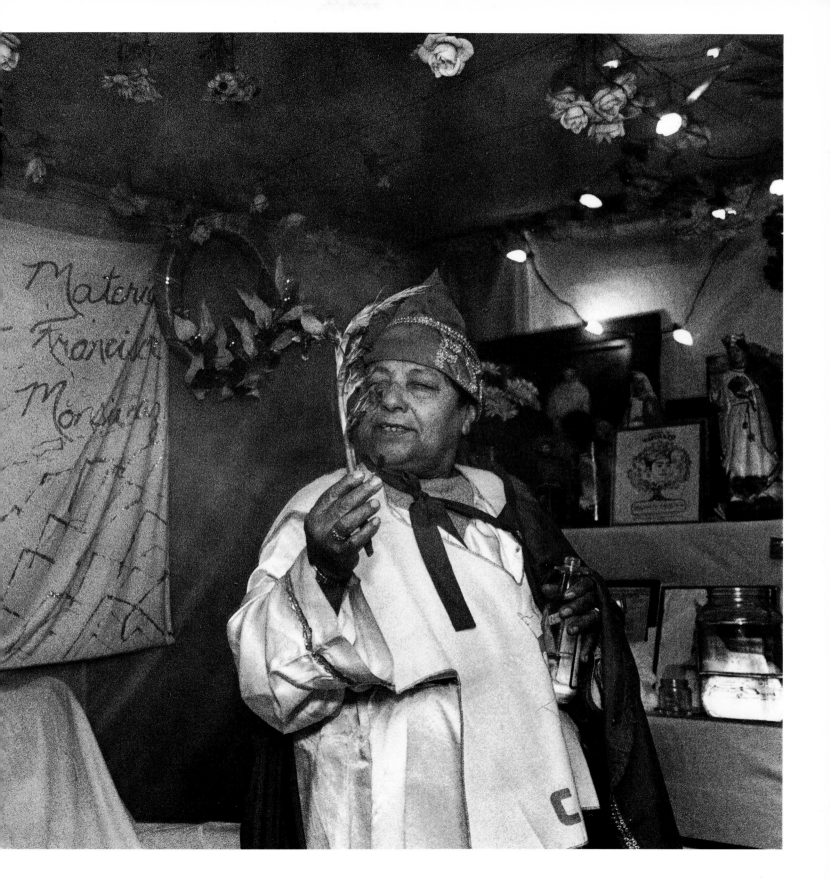

Niño knew that President Calles was coming to Espinazo before he came. He had all the people prepare. He said we are going to show this man that we are a peaceful mission and not what he thinks I am. Niño ordered all the trees to be painted white. Then he ordered all the men to put on white shirts, white pants, and a red material like a bandana and to tie a red sash around their waists. Niño dressed like everyone else as the train approached. The president got there and couldn't tell who was the Niño. Everyone, everything was white. President Calles started looking around—everyone looked alike—until he finally called out, "Where is this Niño Fidencio Constantino?" Niño says, "Here I am." By then, the Niño was standing at his side. The reason he did it was he thought he couldn't just walk up to the president directly—he was afraid the guards might arrest him. The president had used the excuse to come to make Niño a prisoner, but Niñito told him, "I know your real reason why you are here. But first I am going to heal you to prove to you who I am."

What Niño did was break a whole bunch of glass. He finds the right piece of glass. He did surgery on him and cured him of something personal. During the time they are talking: "First I am going to heal you so you see my works and my healings, and then we will heal your daughter." This was the miracle that Niño knew—that Calles had a sick daughter. It was a secret from everyone, everywhere, that his daughter suffered from mental illness.

Before when the president was looking for Niño in the crowds, he fell and hit a big black rock. They went back to the rock and Niño said to him that the black rock was the way his heart was, the bad intent he had for the Niño. The rock had broke in four pieces and broke in a cross. Niño said to the president, "I know you have come to take me, but why have you come to take me? I live here, I help the sick, and I feed the poor. I also have sinners here.

I have pain and misery." Once everything was accomplished to him, he [President Calles] sent Niño whatever he needed, trainloads of clothes, foods to feed his people, and medicines.

An angel appeared to Niño Fidencio telling him he had to go to el pirulito. God has to give him a message there. The pirul signifies where he has gone for all his spiritual help. At the pirulito is where he found his life, where he went to pray and cry, where the mystery lies at the pirulito where God has given him all his strength.

When Niñito died, the doctors wanted to know so badly how he healed people. When they were examining him after he died they found he had a cross on his palate and they knew he was a holy man. They say the reason the Niño looks different in the old pictures was because he was overcome by the Holy Spirit, and when you are a saint you don't ever look the same way—you change your appearances—and because of this photography, we catch this change in appearances.

Riojas Family, Austin, Texas

Niño has been real good to this family. He came to us and told us to build this big tronito for him behind our house. Our mother couldn't straighten her fingers and they hurt so much. Niño said he couldn't straighten her fingers, but they wouldn't hurt so. She always goes to Espinazo. You see, she had a stroke and her face went numb. Niñito came to the hospital, to the intensive care. Niñito came in there for a little while, and she didn't stay crooked. The doctors were so surprised. She is now perfect. The doctors said she would be a vegetable. Everything the doctors gave her made her sick. The Niñito said the doctors are giving her too much medicines. I told the doctors she was taking

too much medicine. *Now they take her off. She is fine. Niñito told her she would remember nothing. She remembers nothing from the past. In the ambulance, I put my mouth to her ear. She was fighting the paramedics. No one could hold her down. I started praying and got on her ear: "Niñito Santos, Niñito Santos, Niñito Santos." She calmed down like it was nothing. Mom, Mom, I am over here. I am with you. She had two more strokes at the hospital, but still nothing happened. The doctors said she would never be the same. I kept praying, "Niñito Santos, don't let them hurt my mother. Niñito, you be the doctors' hands. Don't let them hurt her." The needle they put in her back didn't hurt her. She still goes to Espinazo every year to give thanks. My mother's name is Geromina Riojas.*

Francisca, Natalie, Texas

When my grandson was born, they told my daughter-in-law that he wouldn't survive, and that they would have to do surgery on him as soon as he would be of age, but they couldn't wait anymore. They waited till he was two months old. The day that my grandson was having surgery, my grandfather said he would give his life for him. When the Niñito came, they made prayers and elevated his spirit, and he gave it to my grandson. My grandson did beautifully. He was goo-gooing and eating like mad when before he wasn't eating at all. But my grandfather is going to be my grandson, and they are going to change his name. He died the same time my grandson was having surgery, and my grandfather's spirit is in him. My grandfather was just a beautiful person, and a few moments before he died, he wasn't even sick. He was walking and talking and everything. He decided to give his life to his grandson who was sick. I am sorry I am crying. This happened today. My

grandfather asked for the Niño to come, and he just fell asleep. At the same time, they told me one was dead and one was going to be well. It is a milagro *[miracle]. Grandfather was 104 years old, and he followed Niño for sixty-four years. His name was Ameliano Martínez.*

Materia Anita Rodríguez, Misión Unida Fidencista, Rosenberg, Texas

Sometimes I get asked to go to the hospital when someone is going to die to make sure they are dead if the doctor says they are dead. So the doctors and the nurses leave me alone for a few minutes in the room and the Niñito comes down and says, yes, the person has really died.

Alma Martínez, Castorville, Texas

When you are destined to be a cajita *or a* cajón *for Niñito, he is the one to ask you whether you want to be one or not. He always asks. He never just says, "You are going to be a* cajita *for me." You also have the choice to say no.*

About eighteen years ago when I was in Espinazo, he told me he wanted me to work for him. In order for me to become a materia, *I had to give up too many things, and I was young. When he told me, my heart cried like this sadness that I cannot accomplish what he has accomplished; he was holy. He told me the doors would never close. Whenever I was ready or when I wanted, I was welcome—it was up to me.*

Materia Ma. Elena Oñate, Durango, México

The first time I heard of Niño Fidencio I lived in a small town, Nicholas. It is when I lost my husband eight years ago. My husband was poisoned by a jealous woman. The first time I went to Niñito was to make me a miracle to bring back my husband. I wanted my husband to come back because I had four children. I went to the Niño because my husband was away, and I heard a lot of stories about my husband and I wanted the Niño to bring him home. I found out he died in California. I found out through a dream. Three days after his death, he appeared to me at the door dressed in white. Then he disappeared. Niñito said, "It was destined he was going to die," and that is why he didn't grant me my wish.

Niñito told me in my heart to forgive my husband. I did not know what was happening. I dreamt I saw Niñito in a dream, and my arms were going up. Niñito raised my arms up while I was asleep, and Niñito had my husband in his arms. I didn't know what was happening, but this Niño, he kept coming to me and told me to go to Espinazo. I go to Espinazo for two years before he starts coming through me to heal. I did two healings, but I was not sure what was happening to me. An insane lady had a break-down who I was working on. She was supposed to come back three times for me to work on her, but she didn't come back. She went to a regular doctor and told him she went to a Niño Fidencio. The police come looking for me. The day that the police came by, there were six materias *here. The Niñito asked the police [through a* materia*], "Who are you coming for?" They answered, "Ma. Elena." The Niñito jumps out of my heart and goes into the heart of another* materia. *"No, you are not taking her, and you aren't taking me." So Niñito started moving to all the* materias. *He jumped from one* materia *to another. Then*

Niñito asks the same question in all the materias *gathered. Then the police say, "I don't think we are going to take anybody. I am too confused."*

The Baby Jesus, Guadalupe, Jesus as a grown man, all these spirits, oh, and the Virgen de San Juan de Lagos, all come into the materias' *hearts. And the spirit of Niño also. Jesus' spirit went around and did a ritual. Jesus is going around the circle and left a pool of blood in front of the police feets. One of the policeman then became a* misionero *right there. He couldn't believe his eyes. All the spirits left, except Baby Jesus. Baby Jesus only cures with crackers, candy, cookies, and* pirul, *and with illusions of perfumed water. That is why I also work with the spirit of Baby Jesus and the Niñito.*

No matter how horrible a disease, even if it is a conta-gious disease, it will not penetrate the materia *when working with the spirit of Niño Fidencio. Through Niño Fidencio, the* materia *can cure any disease, can heal all parts of the body, and meet all body and spiritual needs.*

I don't know how to read or write, but I have dreams of the Niño giving me schooling. He gives me little boxes with knowledge in them.

Armandina A. Zuniga, channeling the spirit of the child Aurorita at her mission in Weslaco, Texas, 1991.

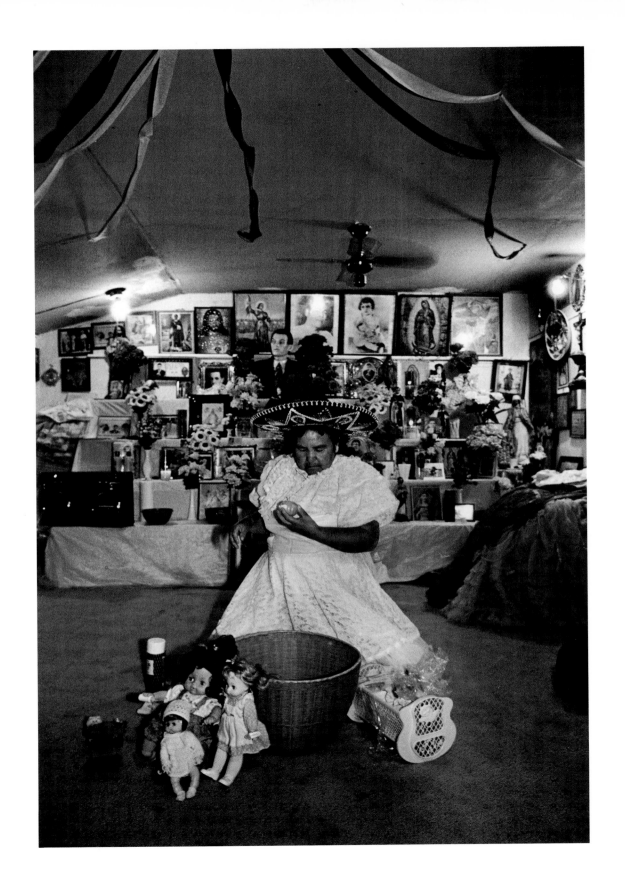

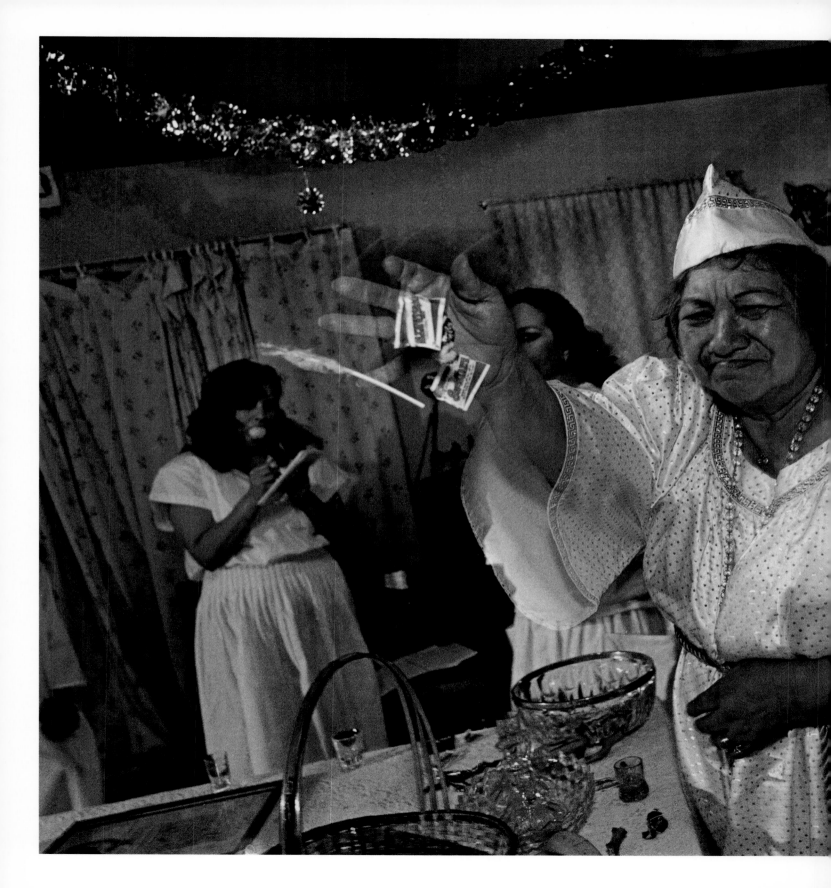

Materia Emma Gonzáles, throwing candy blessed by
the Niño. Austin, Texas, 1990.

Materia Emma Gonzáles, San Antonio, Texas

Sometimes it really hurts standing in the line and walking over the rocks, but you know if you do it, something good will happen to you. Sometimes the Niño's spirit comes to the mission [in Espinazo]. He comes when everyone is sound asleep, and he wakes everyone up, and they go do all these things at three o'clock in the morning. They put themselves through all these things like running barefoot on the gravel. We do whatever the Niño tells us, like into the charco [sacred water] early in the morning, when it is cold.

Niño said, "Someday I am going to come back. Some day, it's going to be a lot of materias." Some of them might be, and some of them might not be. He knew this while he was still alive.

There weren't many materias in San Antonio when materia Olga and I first started. We used the house on Guadalupe Street. Niñito spread the way through Texas. Panchita [another materia] knew about him from Mexico, and Olga was one of the first in Texas.

When I use to go into a trance, I use to see the vision of someone with a very bright light. I just could see the beacon so perfect in my eyes. I always pray to the Virgen de San Juan de Lagos, for it is her I see so bright when I go into a trance. She is my protector every time I receive Niñito, because she was the first one to come in my eyes. Such a nice picture in my eyes. The Virgen came to me when I was praying. I told my husband I would like to go to Mexico to see the Virgen de San Juan because I have made a promise.

So we went to the Virgen de San Juan in Mexico. When we went, we wanted to know something about Niñito. No one told us nothing in the beginning. I say on the way, "Give me some kind of a mark that I am suppose to work with the spirit of Niño Fidencio, something that I can see." Maybe they know more about Niño Fidencio in Mexico.

On the way going, my husband got on the wrong road and kept on going and going. There, sitting on a rock, is a man. I say, "Ask him, where is the right road to San Juan?" I start making sandwiches for the kids.

My husband went to where the man was. He was wearing a white shirt and white pants. He had also a red handkerchief around his neck. My husband says, "We are going to San Juan," and the man says, "You are not on the road. You are out of your way."

I asked my husband to ask him if he knew about Niño Fidencio because he mentioned something about the cerro de campana.

"Oh muchacho. You want to know?" He started talking to my husband about Fidencio. He talked to us a lot, telling us stories about Niño Fidencio, how he was when people use to come to him. I think that he was Niño.

I offered him a sandwich, and he said, "No, give it to your children." I offered him soda, water, and he said, "No, give it to your children." He said, "You all better go. It is getting dark," and he gave us a blessing, and he says, "Keep on your road. You are on the right road."

We said, "Where are you going? We'll take you," and I said, "Get into the car. We'll take you," because I just wanted to hear the way he was speaking to us. He sounded different than a normal person. I knew something was different in him.

He got into the car with us in the front seat with my husband. We had to turn back and get back to the real road. He says, "Let me off," not even a half mile. We shake hands with him. He kept saying, "God bless you all. You are on the right road." He just disappeared right in our eyes. We lost him walking down the road. We kept on walking. Where did he go? We kept on looking where he went, and we never did see him again. He just looked like

an old man. He was kind of old, but he looked like Niñito in a way, and that is when I said, "Niñito put him there." Maybe Niñito was in that man's spirit. We had learned so much about things of Niñito when he was alive. We were so grateful to that man. He also explained to us Niñito died when he was still alive.

Richard Zelade, Journalist, Austin, Texas

At these seventy-two-hour healing sessions, he would lose all concept of time, and his followers were already beginning to regard him as a supernatural being on the level of Jesus. Therefore, when don Enrique would take him away to get something to eat or get some rest, they would get pissed off. They couldn't accept the fact that he was a human being, and there was this resentment that began to build to don Enrique because he is taking our Niño away from us. That is one of the reasons why he died. He basically worked himself to death. He had pernicious anemia, a form of anemia where you bloat up and get fat. His health was failing him, and when you die of pernicious anemia, it is a slow death. This went on for a year or two. He spent the last few months of his life bedridden. He lost more and more strength every day. He was in bed the last six weeks of his life.

The way the followers tell it is that he was such a spiritual man and what happens when you are such a spiritual man, your body swells spiritually, and he had to keep renewing his spirituality. It wasn't fat, it was his sense of spirituality that puffed him up. Towards the end of his life, he was getting thinner and thinner. To the people, the reason he went into this three-day trance was to puff himself up again with spirituality.

The slit in the neck was from the embalming process. I have had doctors explain this to me before and how it was mistaken for fresh blood, the bodily fluids. Doctors tell that a lot of people don't know this and explain this fluid for blood and say he is alive when he isn't. When he was dying, he asked don Enrique to stay with him. Don Enrique was holding him in his arms and said he was actually afraid of dying for a little while, and finally he calmed him down and said he was going to be with him. ("Why would he be afraid of dying if he was working for the Holy Spirit?") I haven't been able to figure that out. He didn't know what he was doing, a little voice spoke to him and told him to do this and that. He was a very simple man. He wasn't very well educated. What he did was from instinct. You might call it a voice that came to him.

When he died, his followers surrounded the house. Don Enrique wanted to bury him because he knew he was dead, but they were so fanatical about it. They wouldn't let things pass, and it got real tense. It had to be done; that was the law. And when the doctors came from Monterrey and pronounced him dead, they also did the embalming because in Mexico doctors do a little bit of everything, and they make the slits in the jugular to drain off the blood to inject the embalming fluid—that is where the throat slitting comes from. If you look at photos, his throat is not slit. There are photos of the doctors in their masks doing the little jugular cuts. There is no slit in the neck, and he is puffed up. The guy is dead. You know how hot it is in October?

They equated him on a level with Jesus. The three-day thing was just too strong, the symbolism, for them to ignore. Don Enrique had to get special dispensation from the government to bury him in the house because normal law doesn't allow you to bury someone in the house. It was a real tense situation when the doctors came.

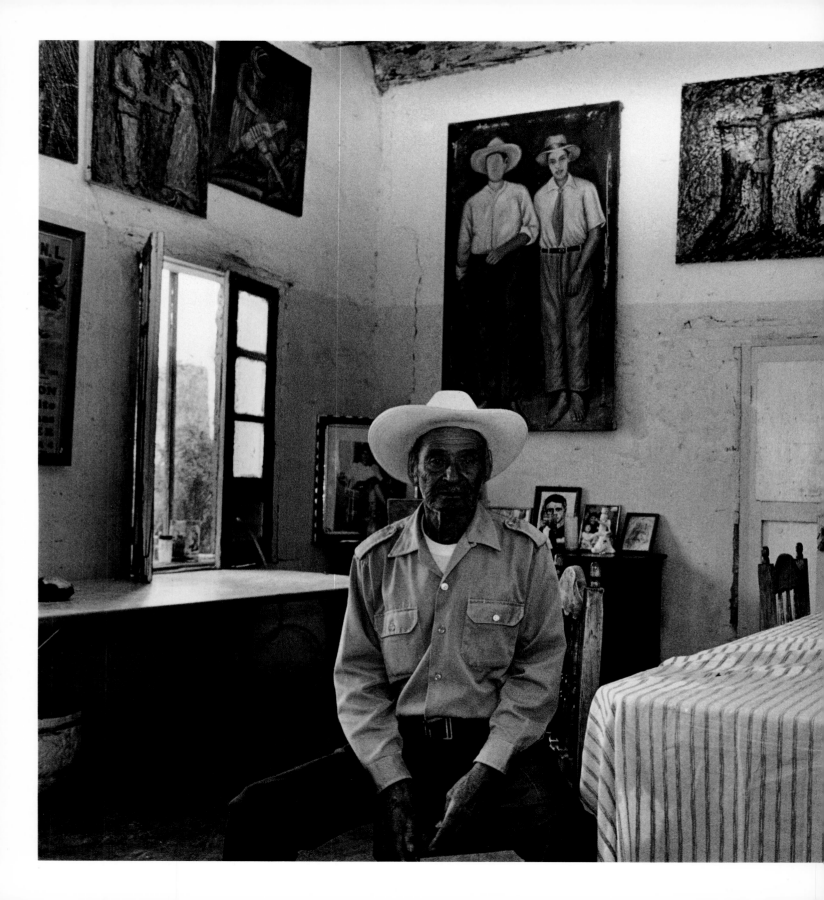

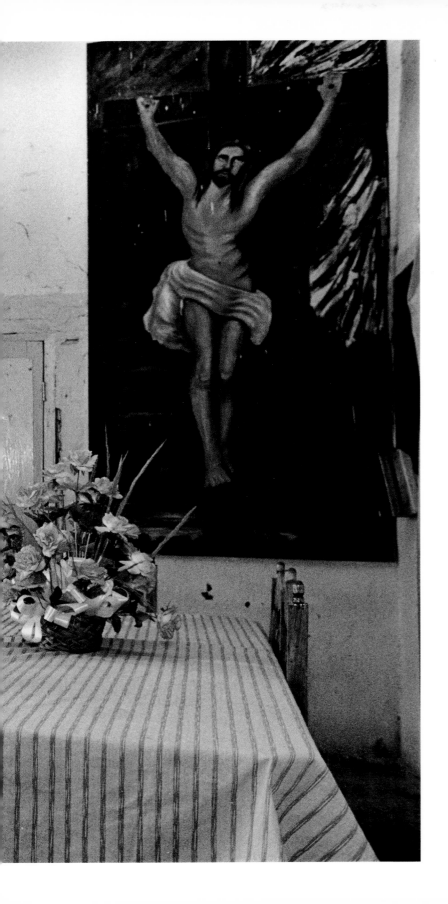

Don Alejandro in the salon of the hacienda. Espinazo,
Nuevo León, 1990.

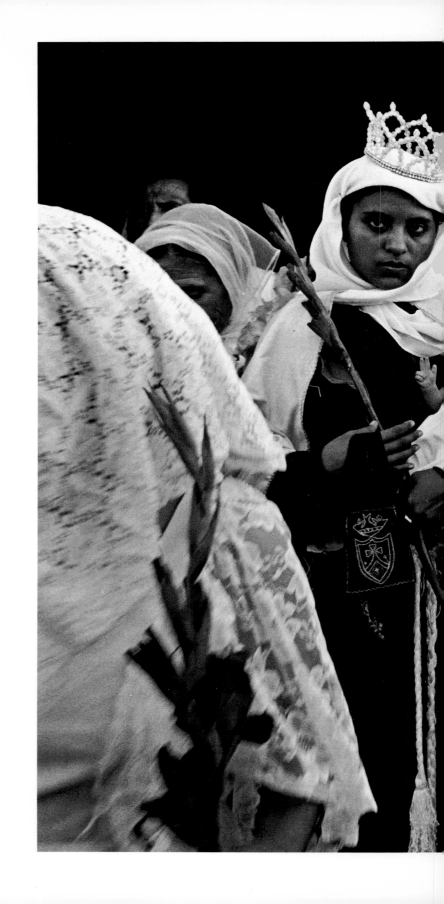

Outside the *tumba*. Espinazo, Nuevo León, 1988.

94

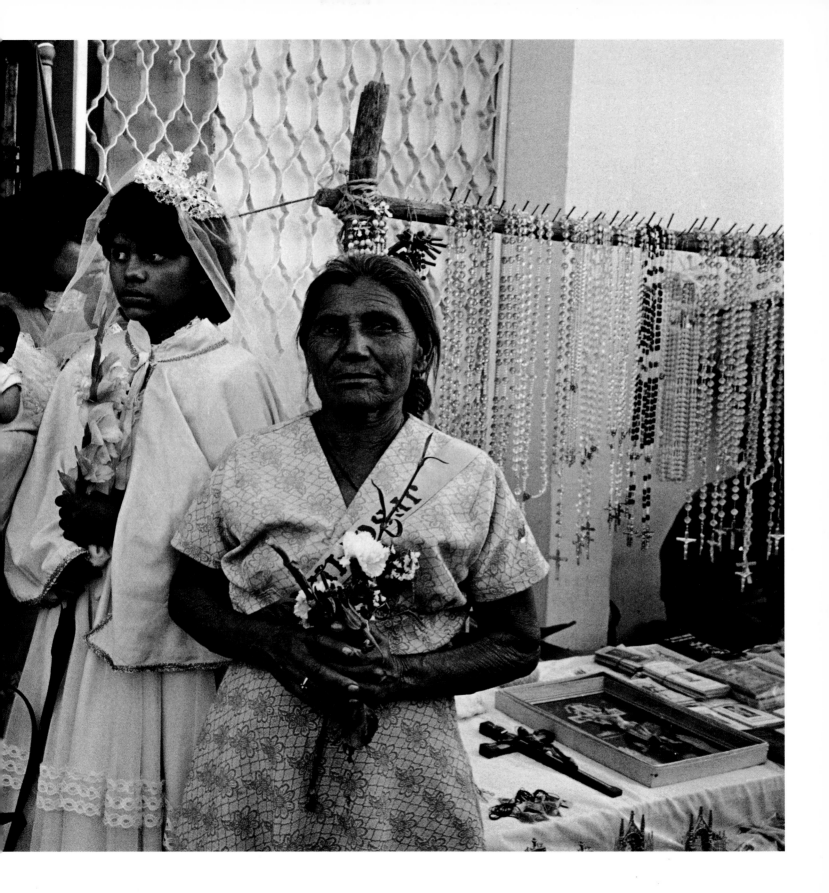

Espinazo, Nuevo León, 1988.

96

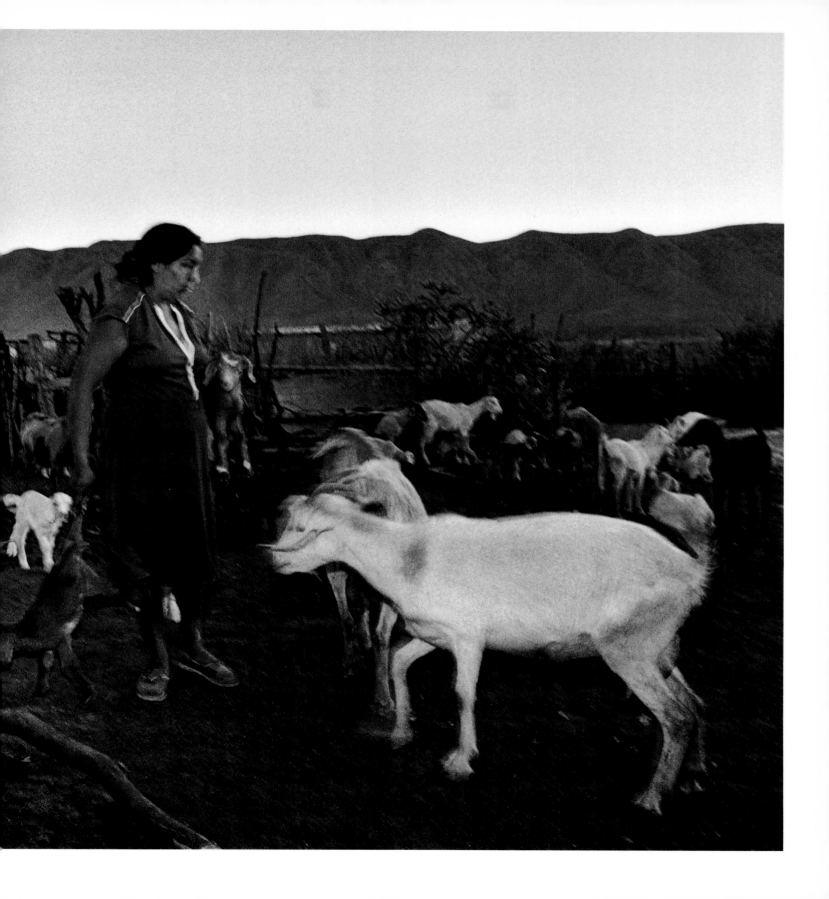

El torbellino. Espinazo, Nuevo León, 1991.

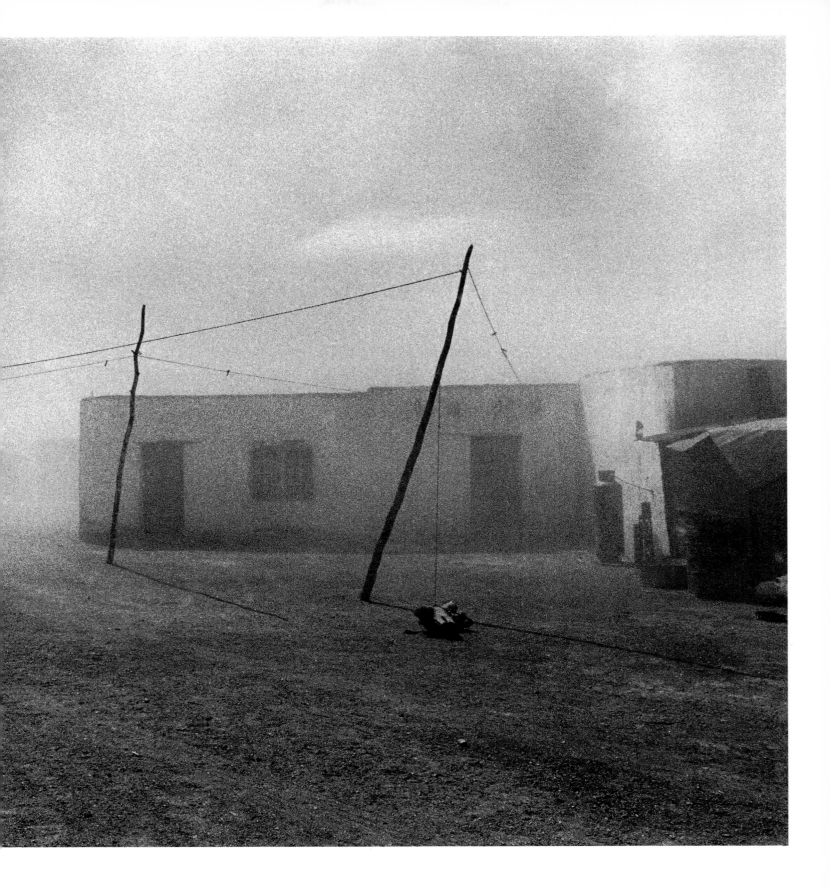

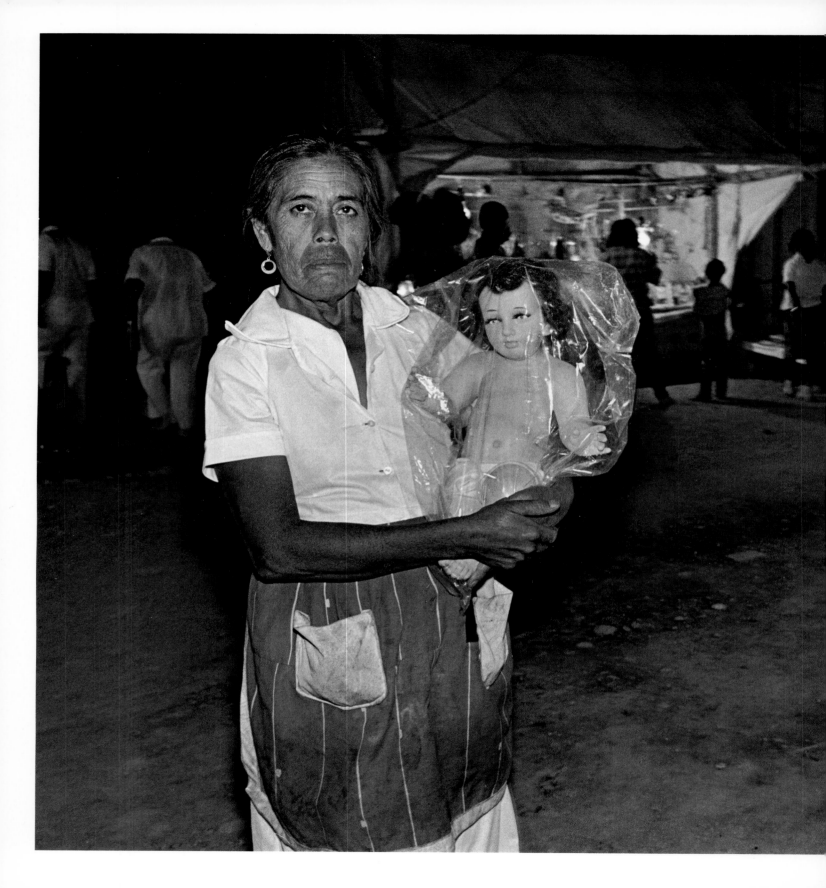

Espinazo, Nuevo León, 1988.

Espinazo, Nuevo León, 1988.

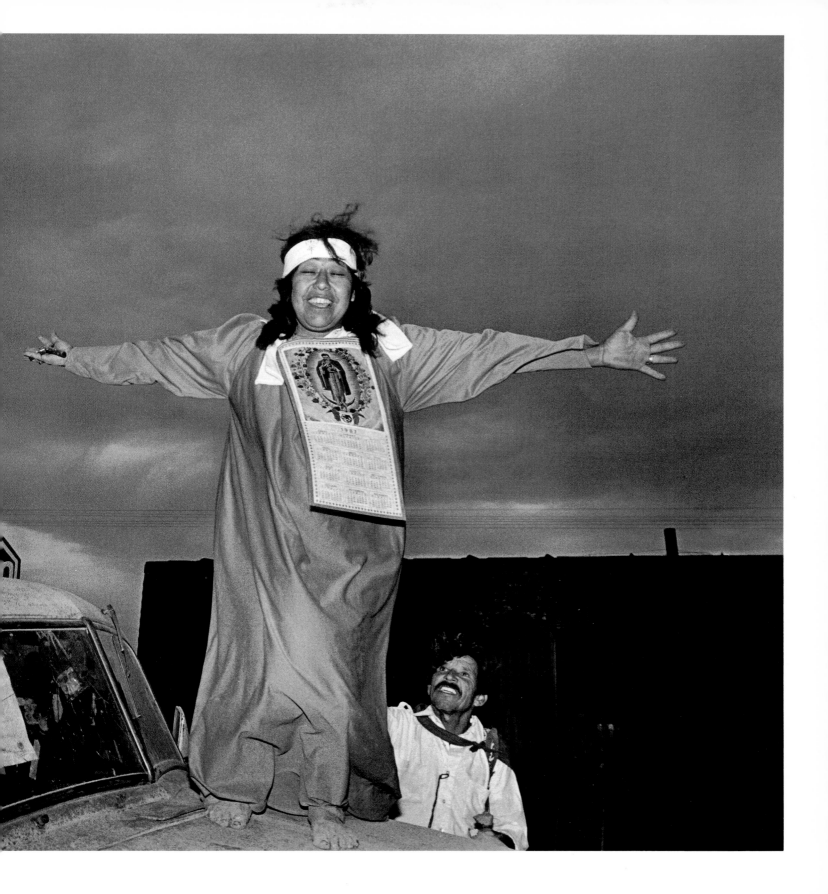

Materia Nicholosa Henry, Lomita, Texas

*This lady was in a coma for nearly two months, and no
one could do anything about it, and her folks didn't know
about Niño or nothing. She was just in a coma all by her-
self and friends said, "Why don't you call the* materia?"
*So they called me and I went up to see her, and Niño said,
"When you go, take a lemon." This is what he usually uses
the most. He says, "Leave it overnight in the altar, and
take a lemon with you and rub her all over her head. Go
twice across from the front, like a cross, with the lemon
and clean her head real good. Make a cross, and then
call her three times for me and she'll come back into her
body. Something shocked her out of her body, and she
can't return. She is alive, but someone has to help her
come back to her body."*

*Everyone was waiting for her to die. I go in there and
do what Niño tells me. The nurse wanted me to get out of
the room because she was saying I was doing witchcraft.
Next day they [the family] call me: "It's a miracle. My
mom has been eating and talking since you left." Now
these are really people who really gets up my spirit. They
are the ones who need Niño and can't get ahold of him
right quick.*

*Not too long ago, my nephew died. He had leukemia
for over a year, and nobody knew it. When the doctors
tested him, they couldn't find the leukemia, and when he
came here from California, I told him, "You go see a
doctor. I don't like the way you look."*

He says, "What do you mean?"

*I says, "Your eyes. They start to get white on the
bottom of it, and I don't know what the respond is, but I
know that it is no good."*

*I took him to my family doctor, the one who take care
of me. [He] told him it was leukemia and he had it for over
a year and there was nothing they could do about it. They
were going to try it, but they weren't promising any-
thing and Niño had already told me he was too far gone.
He says, "There is nothing I can do about it. I'm sorry.
Just do whatever he wants and try to keep him happy and
look happy for him because if you look worried, he will
start worrying." And sure enough, he didn't even last us a
week. It was just a couple of days, and he went so quietly.
He use to say, "Why don't you come and see me as often
as you can," and I couldn't go for the reason I felt so guilty
that I couldn't do nothing for him, and yet he was expect-
ing me to help him out, and I felt all that guilt, and every
time I went in there, I thought, "What good am I if I
can't help him out?" It was like Niño said, "There are
certain points when God says, this is your time and your
day, and there is nothing or nobody that can stand in
their way, and we have to learn to accept those days,
those heavy loads." That is what he [Niño] calls it, heavy
loads. And he said, "If you learn to accept it you will be
all right."*

Sara Sifuentes, San Antonio, Texas

*When I first went to Espinazo, I didn't know what it was
like. I wore high heels and had my hair set and went to the
beauty shop because I thought it was that way.
I wore my new dress. When we arrived it was three o'clock
in the morning, and I was all dressed up, and Niñito
came and told us to do* penitencia *and I went into the*
charco *pool all dressed.*

*When Niñito operates on people, the surgery, the lady
laid down, and he put a sheet on her and you could hear
that she was cut in the skin. He had a glass of water,
and he put a lot of things from the stomach in the water.
I didn't see the stomach open, but I can hear. Then he*

said, "Tomorrow, don't give the lady anything heavy, just love and sopa [soup]." And they got well. They got well. Emma [the materia] doesn't remember doing anything like that. She just knows from us telling.

Once Blanca had a toothache, and Niñito pulled it out right in front of everybody. It don't hurt Blanca at all because Niñito did it. He does things that you can't explain.

Mrs. Sifuentes is eighty-one years old. She still makes the trip to Espinazo at least once a year with her mission.

Don Alejandro, Espinazo, México

I never criticized the doctors, but what Niño did was so miraculous doctors couldn't do it. That is one of the reasons the doctors didn't like him. No doctor in this world ever did anything like Niño Fidencio did. He would also use for the operation the glass and a herb, gobernadora, that grows. It is so strong in operations. This woman came to him with a very large stomach. Niño used the goberna-dora sticks and punched three holes in the stomach. Then he ordered the helpers to bring a pan, and Niño would squeeze junk out of the lady's stomach, poisons and fluids built up in her stomach. She got well in eight days.

All Niñito ever had was God to look up to; he was an orphan.

Nurse, San Antonio, Texas

I was sick for two-and-a-half years. When I came to Niño Fidencio I had my doubts, but this lady told me about him. She told me somebody got to help you, and I know the person. When I first came, he told me, "I'm not going to hit you or hurt you." He told me he was going to heal me, and in the week I was well. I couldn't believe it after two-and-a-half years going to doctors.

Doctors are human. A lot of times they are guessing by what the patient is saying. Niño Fidencio is different. He'll take care of you if you just give your heart to God. You feel the change. I have a feeling that I might become a materia. Niño told me I was going to serve God and him. He told me I was a clairvoyant. For a lot of years, I knew what was going on and I said, "Oh Lordy, help me." It scared me. But he [Niño] helped me and I'm not scared and I am really grateful to God. I feel closer to God, and I can help my patients better.

I always had faith in God and I always prayed, but since I met Niño Fidencio it is like now everything you do with more faith and more frequently, and you get hurt a lot more. It is something that comes from your heart, and you seem to see more things and understand more things. I wish it would happen soon, but I am going through a trial to see if I really love God or not. Understand first that it is God that is doing everything, and Niño is here because of God. It is the Niño when you have thoughts and you are with him, he'll tell you the thoughts that you are thinking. Things that are very important to you, he will tell you. Some say you need a glass of water and call him three times, but a lot of times you don't need that. You just call him with faith and you can smell his perfume. I feel safe cause he is always there for us. When you have a lot of faith, you see a lot of visions, holy things. Everything is clean and beautiful when you are praying, and you call Niño. You can also feel him in your head. You can actually feel him with you.

Alma Martínez, Castorville, Texas

Ma. Elena said it is like your ears are covered. Others say they feel like they are present but not present, in the sense that they were in control. They weren't. They were just there. That's when the spirit has taken over. You can control him [Niño] coming to you. He respects you whatever you say.

Sometimes when I would go to the Niño, I would have to wait up to seven hours to see the Niño, and from there grew my patience. You just sit there and wait till they bring Niño down.

A cajita, a materia, meaning the same. Different places, different names. Niñito is everywhere. He told us that one time. He said no matter who the person is, I will always be the same person. I am only one Niñito, but I can come in each person. You can tell that Niñito is the same one because of his words, his ways. The blessings are the same, the talk is the same, and in fact his spirit will always recognize you. There are a lot of things I'll never forget. It is like life. Whenever he talks, you are enlightened and you never forget it.

Last night I asked Niño about his death, and he said he had told the people that he was going into a trance for three days, and he was going to receive the Holy Spirit in his body, and his body was going to swell up, and after a couple of days one of the ladies of the mission who had already died from that era, she called the doctors from Monclova to come and check why was he like this, swoll up, but Niñito had said that he was going to get the Holy Spirit in him and that was why he was going to swell up; all the energy was going to go into him. The doctor decided to cut him from one ear to the other, right around his neck, so he would examine him. Niño said that he [the doctor] pricked his finger, and that after he cut

Niñito's neck he just left him there like that. He didn't close him up or nothing. He just went back to Monclova. As soon as he walked in the door of his office, he fell. He had passed away, but Niño said he had took him with him.

Reverend Alberto Salinas, Jr., Pastor, Primera Iglesia del Espíritu Santo, Edinburg, Texas

Von Bernich got sick and heard about that Niño. The people claimed that he had healed them and that he delivered babies, and he was like a doctor. He needed medical attention and had him brought over. He had tried to get medical attention in Texas, and no one helped him. He was on his deathbed. They brought Niño, and Niño told him he could make him well and that he needed some things, medicines and things to operate. He told him what he wanted, gave him a list. He told him he had eaten a fish bone, and the bone had gotten stuck in his stomach, and he had an infection in this stomach. He told him before he opened him up. He did open and operate. But he knew before he opened him up. He fixed him and he became alive and he got off his deathbed. [Some say he cured Von Bernich of ulcers on his leg by bathing him in a tomato-based liquid.] When he got well, this is what he did. He got the word around that Niño healed him, and he publicized this and other miracles in a Mexico City newspaper. In gratitude, to make it known, he had the healing powers of Niño published. People started hearing about the miracles of Niño Fidencio, thousands came to Espinazo, this was around 1928. There were a lot of things going on at this time and now, a miracle healer of the people.

After the Mexican Revolution was the War of the Cristeros, problems with the Catholic church because the Mexican government wanted to educate people, send them to public schools, and the Catholic church stood in

the way. Mexican people outside the big cities didn't want their children to go to school and get an education. The priests would tell the people that it was not a good thing to get an education. In every small town, there was a Catholic church against the government and the government was against the church, and they got into a war. It got as big as the Mexican Revolution itself. Calles came to see the Niño, it was 1928, he had one of the biggest followings in the nation. Everyone killing each other and the president of Mexico is going to see Niño Fidencio to meet with him to see Niño in spite of all the fighting. Niño said, you have this daughter that no one knows about. You had her put away. Calles knew he was special because no one knew about his daughter. That helped Niño a lot. Niño would always get what he wanted from Calles. He was now famous throughout the country.

He wasn't much of a showman. People put him up to it for publicity. This bothered him nearly as much as all the suffering he saw. Even though he had all these powers, to see all these people coming to him, wanting him to help, but they don't at all understand what is this all about. It must have saddened a man like that at times. Spiritually, was he getting somewhere with the people all around him? He was taking care of the physical problems. He can give them herbs and teas—but their morals. That was what was breaking him down.

His mission is to continue doing good for the people. He did it in the material world, and now he is doing it in the spiritual world. He does more after his death in terms of preaching moralities. He tells you to be good, and he guides you, and he works more on the soul now that he is dead. So he is in a different state. His job was not finished. It couldn't be done in one life.

I was a pretty rough old boy. He changed me and helped me. When I first heard him speak in a materia, I was overwhelmed. His spirit or his voice just when he talks to you, it changed my whole life. I was ready to change; I wanted to change. He was my entry into that world. That world is large. It is greater than just him. You feel like love for the whole God-like aspect of it. His job is to see for the one who could not see for himself—to do for the one who could not do for himself.

Materia Francisca Monsivaíz Aguirre (Panchita), Misión Fidencista Jesús Sacramentado, San Antonio, Texas

When Niñito was lying in state, thousands upon thousands of people were making penitencias to relieve their pain and their soul that Niñito had died, and down at the pirulito was the very first materia, Elvirita Tamez. Niño Fidencio's spirit came down in her. He came down and said, "Please quit crying, and please quit making penitencias. Please stop. I am here, I am still here with you. I am not gone. My road is not yet finished." Niño was talking to the people. The people started turning back and looking and hearing Niñito's voice in the materia. He said that even though they have killed his body, his spirit still had to keep on working and was going to continue to come until God said he wasn't going to come anymore. There was a song being sung by Niño Fidencio that was the highest. That was the song that was expressing when the spirit of Niño is coming, it is a blessing song. All of that song states what is Niñito: that he is not going to leave and he is going to keep on working to that very day. Also it tells what is a Fidencista. All was being said there that very day: the materias are going to be like vessels and the spirit is going to come into the materia.

Adiós, ángel mío.

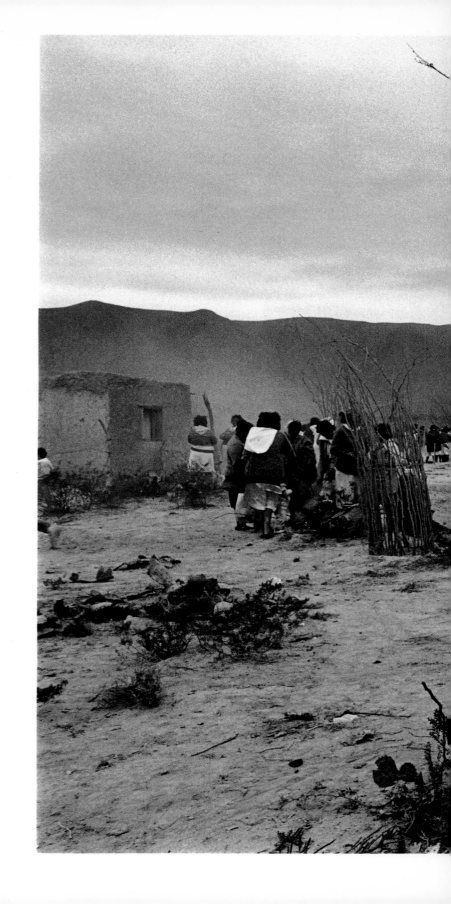

La dichosa, where Niño cured lepers and *loquitos*.
Espinazo, Nuevo León, 1990.

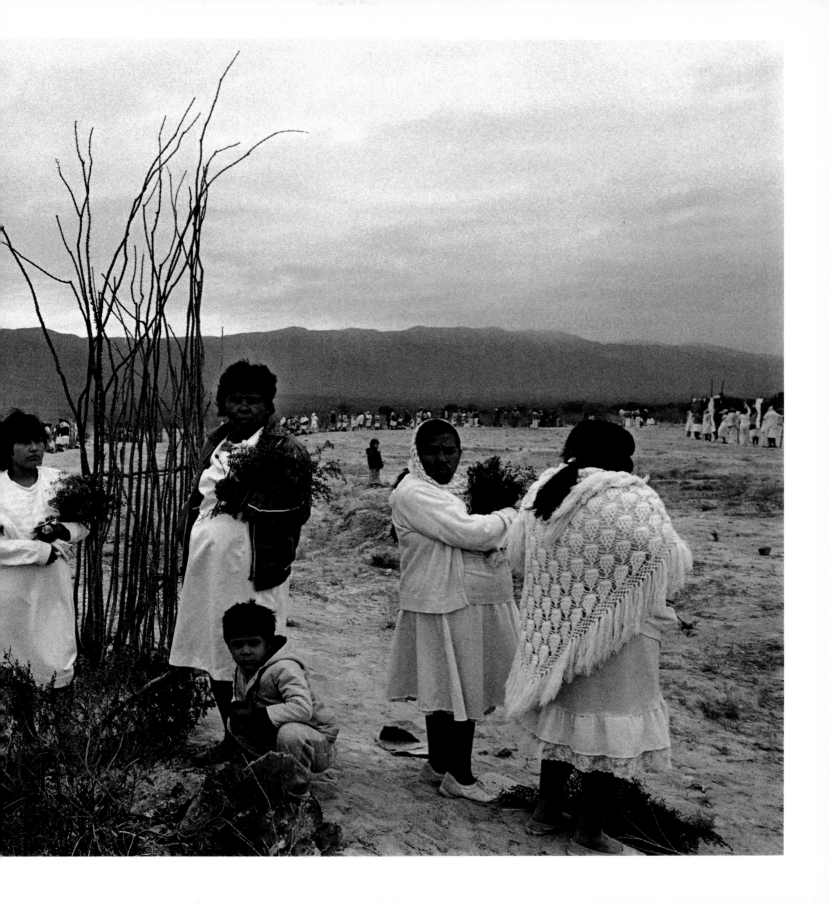

Octaviana Torres Davíla. Espinazo, Nuevo León, 1987.

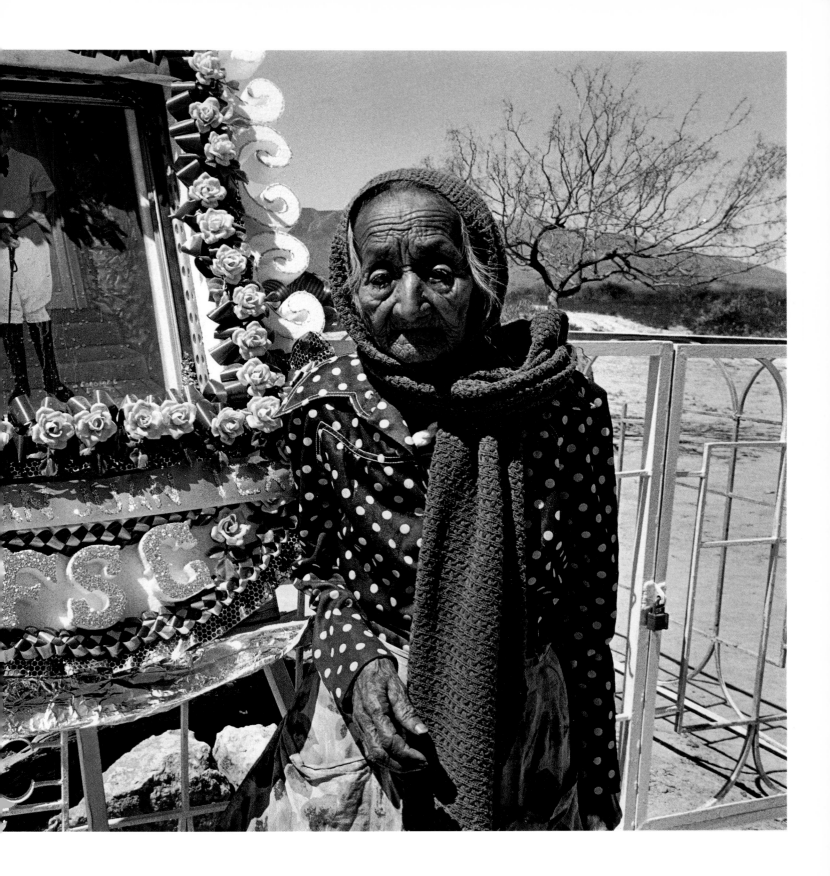

Espinazo from the train, 1987.

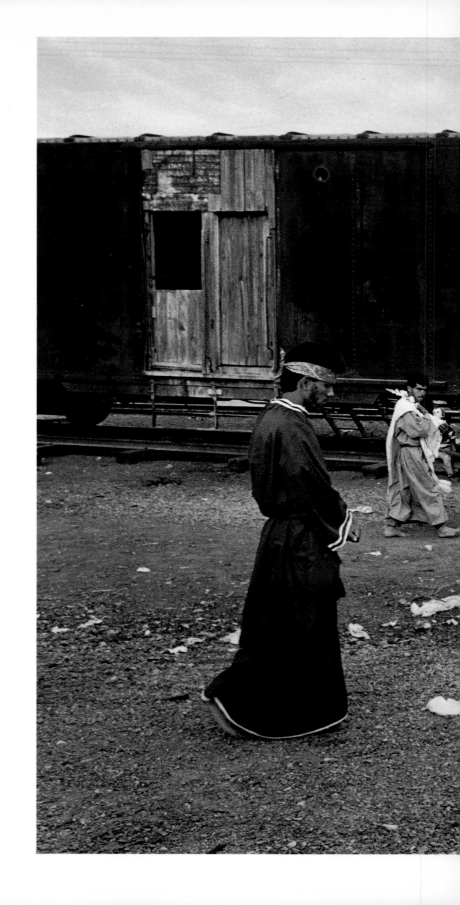

Espinazo, Nuevo León, 1990.

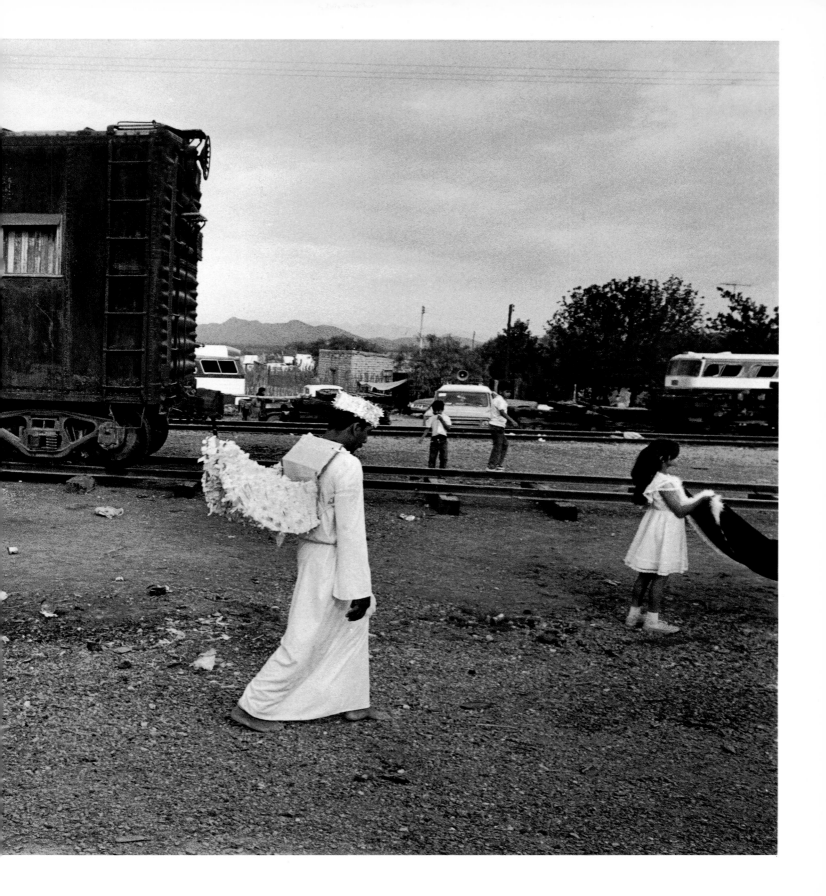

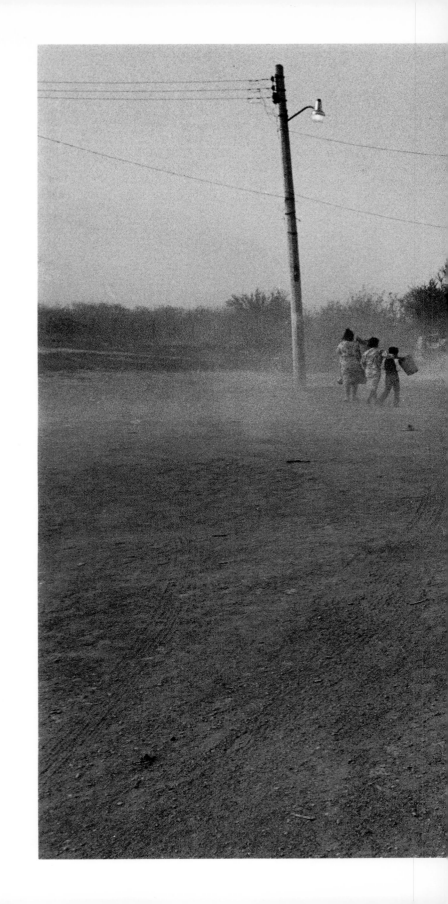

Up from the *pirulito*. Espinazo, Nuevo León, 1987.

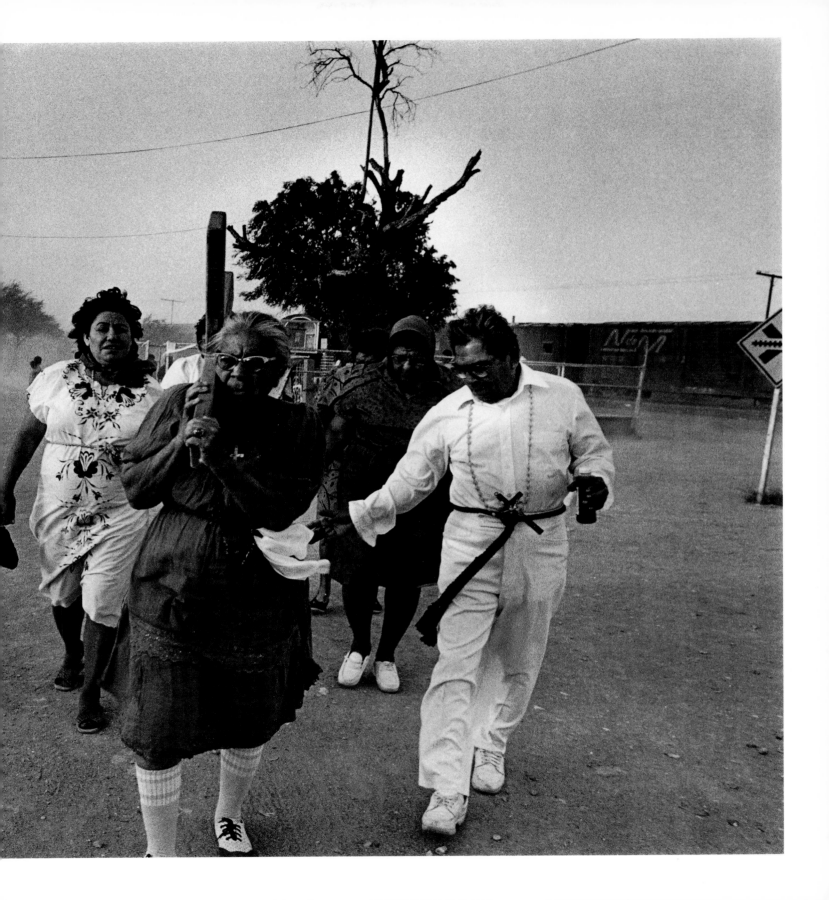

Materia Ma. Elena Oñate, on the road to the *cerro de campana*. Espinazo, Nuevo León, 1987.

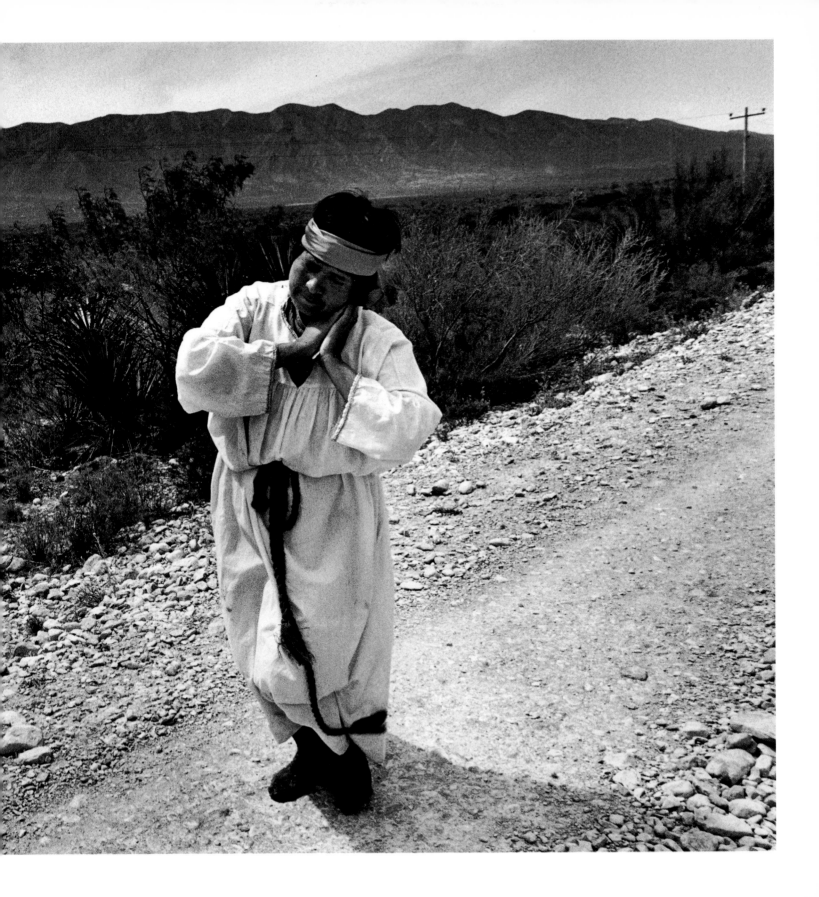

"Because of This Photography": The Making of a Mexican Folk Saint

Kay F. Turner

Espinazo, a tiny Mexican village in the state of Nuevo León, is outwardly what some would call a nowhere place. The way to Espinazo is difficult, down a rutted, unpaved, dusty road that is often impassable. Hardly anything exists in this out-of-the-way spot. There is no hotel, no café, no gas station, no public monument, no park—nothing there, really, but a tree, a tomb, and an old hacienda. And yet these landmarks are enough to draw thousands of people who twice yearly for well over half a century have taken the road to Espinazo in search of a certain kind of fulfillment. They have gone there on religious pilgrimage, that ancient form of travel that leads from home to a version of heaven by way of contact with the place where a saint once lived or is buried or is said to have made a miracle occur.

In Espinazo one finds the tomb of a "sainted" man known as Niño Fidencio Constantino and also the sacred tree, called *el pirulito*, where it is said that this man received his powers from God to heal and care for the poor and sick. During his lifetime in the early part of this century—a period turbulent with change in Mexico and in the world beyond its borders—Niño Fidencio became a charismatic figure who drew followers from all over northern Mexico and south Texas. By the time of his death in 1938, Fidencio Constantino's Christ-like persona had inspired the formation of a cult of ardent believers that remains active today among Mexicans on both sides of the Rio Grande. Indeed, this relatively unknown cult (*cult* meaning simply the particular system of collective worship or devotion directed to a deity or holy person or venerated figure) continues to grow and exemplifies the great degree to which Mexicans assert their religious traditions cross-culturally. Belief has always been a binding force in the Mexican community wherever that community is encountered; thus it is no wonder that followers of Niño Fidencio may be found in Mexico City, in Nuevo Laredo, in San Antonio, Texas, but also as far to the north as Seattle and Chicago.

In many ways, Niño Fidencio fits the cloth of sainthood that has distinguished the practice of Roman Catholicism since the early centuries of the church. The cult of the saints began as a way to honor the first Christian martyrs persecuted under the Roman state, but it soon became a vehicle for popular piety; believers came to choose the meaning and relevance of a saint's life and works according to their needs and desires.[1] Niño Fidencio is not a canonized saint and it is unlikely that he ever will be, but among folk practitioners of Catholicism in Mexico and elsewhere sainthood can be achieved by the popular acclamation of believers, not solely by the approval of the church institution.

Historically, the task of becoming a saint has had much to do with the creation of his or her reputation through good works and the performance of miracles. In addition, the task of remaining a saint—that is, remaining active in the spiritual life of the faithful—has had much to do with believers' traditional ways of maintaining contact with the saint's power through access to the physical presence of the holy person. In Roman Catholic

culture, holy images and pilgrimages are the two most commonly applied traditional resources for keeping saints "alive" long after their earthly mission is finished.[2]

Active believers in Niño Fidencio dedicate themselves twice yearly to accomplishing the long and strenuous pilgrimage to Espinazo. By so doing they, like the more well known pilgrims to Compostela, Lourdes, Fatima, and Guadalupe, participate in an ancient migration that step by step and mile by mile brings them to the physical and historical source of their belief. In the Christian world, pilgrimage finds its most celebrated epoch in the European Middle Ages, but as the Niño's believers exemplify, the tradition persists today.

The arduous journey of pilgrimage functions as a kind of purifying penance the reward for which is an intense feeling of religious revivification and an opportunity to forward prayers, thanksgiving, and petitions to a saint

at his or her primary shrine. The movement of pilgrimage is always from lesser toward greater spiritual power, symbolized in the journey from the mundane world of home to the sacred site of the shrine. By virtue of its designation as a pilgrimage goal, the otherwise unexceptional village of Espinazo becomes a place of heightened spiritual gratification. For Niño Fidencio's followers, the struggles laid before them are endured with deep, often ecstatic gratitude for the opportunity to renew their relationship with him, to seek the beneficence of his healing powers, and to thank him for his presence in their lives.

Where saints are concerned, remembrance of them and relationship with them are fortified by the replication and distribution of their bodily images. Saints—both folk and church-sanctioned—are human and therefore bodily intermediaries between heaven and earth. They are visible bodies who understand the needs of other bodies, and therein lies their appeal as holy beings who assist an invisible God in the performance of miracles that answer human needs and desires.

In the first centuries of the church the veneration of relics, the actual bodily remains of the saints and martyrs, gave early Christians palpable access to the human history of their holy figures. Later, painters and sculptors of the Middle Ages serviced every Catholic community in Europe by representing the life of Christ, the Virgin, and the saints in their works.

With the invention of the printing press came the slow but inexorable development of means by which holy images could be replicated cheaply and distributed widely. By the middle of the nineteenth century, urban-centered Catholics had access to inexpensive chromolithographs of their favorite saints printed and distributed in the form of portraits, holy cards, and chaplets used expressly for personal devotions. This same period saw the invention

LA SRA MARIA MAR
TINES SUFRIO 4 MES
UN PECHO, DE UN
SARATAN Y DE EL
INTESTINO. LA OPERO
EL NIÑO FIDENCIO,
Y EN 21 DIAS QUEDO
SANA COMPLETAMENTE
SP. N. L. 12/30/2

and gradual absorption into popular culture of the most revolutionary image reproducer of all: the camera.

By the turn of the twentieth century the camera was transforming the human ability to produce, process, and absorb images. Inexpensive mechanical reproduction gave people a new and ready access to secular images of popular national figures, but perhaps more than any effect it was having on the history of the image, photography was now available for documenting and replicating images of "living saints." In the period that includes Niño Fidencio's life, other saintly men and women in the Catholic world, such as Bernadette of Lourdes, Mother Cabrini, José Gregorio Hernández, and don Pedrito Jaramillo were for the first time being caught in the camera's eye. Photos of them became a part of their holy posterity, just as

paintings and prints had been for saints of earlier periods.

A distinguishing factor in Niño Fidencio's rise to sacred status is the extensive role played by photography in documenting, preserving, and enhancing the powers of this holy man. More than is true for other saints who have emerged in recent history, Niño Fidencio's cult largely thrives due to the widespread duplication and distribution of photographs of him taken during his lifetime—photos that record the life of a healer and charismatic figure who might otherwise have remained unknown beyond his lifetime. Perhaps even Fidencio himself realized the potential of the camera as a device for rendering his miracles more believable. One remarkable photo shows him sitting beside the bed of a recently cured patient—holding a camera on his lap. Given this predisposition toward the camera, it becomes almost an inevitability that a photographer should be "called upon," as some of Niño's followers believe of Dore Gardner, to further the Niño's mission.

Niño Fidencio's Life and Legend

Aside from the evidence presented in photos of him, what is known of Niño Fidencio's life and works primarily is stored in the memories of his followers, who call themselves *fidencistas*.[3] Very few who knew him personally or were healed by him directly are still living; most *fidencistas* today relay secondhand the facts and stories that constitute Fidencio's sketchy biography. As with tales told about any extraordinary and influential person, these stories lend themselves to contradiction. In the stories of holy men and miracle workers, authenticity often is a mere invention anyway. What remains effective in legends of holy figures is their instructiveness, the way they serve as testimony for the nature and power of belief in God and belief in those who are chosen specially to reveal God's love for humanity.

José Fidencio Sintora Constantino was born in Guanajuato in 1898 and lived most of his adult life in the village of Espinazo in northeastern Mexico. He came there to work as a housekeeper at the hacienda of an old friend. From a young age (some say as young as eight years old) Fidencio expressed an interest in and a talent for *curanderismo*, the traditional system of healing that combines belief in the supernatural (usually including patronage of the Catholic saints) with specific knowledge about medicinal plants, potions, rituals, and other remedies that are part of a very old body of medical folklore in Mexico.[4]

In Espinazo, Fidencio slowly gained the reputation of a *curandero* (traditional healer). Those who knew him report that he was an engaging but humble man—not well educated—who worked out of instinct, lore, and great

faith. By any usual standard he should have remained a local practitioner of the healing arts, but Fidencio possessed a kind of charisma that set him apart.

His followers gave him the affectionate name El Niño (or simply Niño or Niñito), meaning "Child of God." People who knew him say that even in his adult years he retained a soft, boyish look and a certain innocence. Fidencio never married, and it is likely that he remained celibate throughout his lifetime. All reports suggest that he was a profoundly gentle, generous, and open man who took very seriously his work as a healer. But it also is said that Fidencio had a flair for drama; that he often acted in a playful, childlike, somewhat effeminate way; and that even his adult voice retained a high-pitched and childlike quality.[5] Our picture of Niño probably will never be complete. He was a bit of a contradiction, a bit of a friend and a stranger—unknowable but well known in the way that godly figures sometimes are.

Still, the most compelling evidence about him suggests that Niño Fidencio was a very talented healer who combined traditional curing methods such as herbal remedies with his own imaginative techniques, including bathing cures and the removal of tumors with specially chosen pieces of broken glass. (It is thought, too, that Niño was aware of and practiced certain of the newly popular Europeanized versions of yoga, meditation, and astral projection.[6])

Fidencio was by no means a preacher or dogmatist. He used play, drama, and catharsis in the act of curing. His obsession was with the physical; he let healing miracles of the body speak of a spiritual capacity that he believed required no other articulation in words, ideas, or instructions.

There can be little doubt that Fidencio Constantino was gifted and that his cures were successful. By the late 1920s he was drawing thousands of people to his care.

Believers would camp out for days awaiting his attention. His miracle healings became legendary. To this day the story circulates that in 1928 Fidencio was paid a visit by the president of Mexico, Plutarco Elías Calles. It is said that he cured the nation's leader of a serious chronic ailment, moving Niño beyond the realm of a traditional *curandero*. When he died in 1938 he was the most famous healer in Mexico; he had taken on the mantle of a hero, a cult figure, and a saint.

Still, Niño himself professed no special status. In fact, some say that he resented the growth of his fame and notoriety. Nonetheless, his reputation as a healer and as a spiritual leader grew in proportion to the legends and stories that developed about his miraculous abilities during his lifetime and even after his death. These stories help legitimate his power and form part of a repertoire of narratives that structure the current practices of Niño's followers.

* * *

The remarkable ascent and continuing influence of Niño Fidencio is explained in part by situating them historically in terms of class, contingent political events (the Mexican Revolution, the Cristero rebellion, massive immigration to the United States, economic depression), and the general social upheaval in Mexico during the first forty years of this century. This climate of disruption created the perfect atmosphere for the rise of a distinctive religious personality, especially a healer and miracle worker. Fidencio's avowed access to direct power from God; his guilelessness combined with his individualistic, but also very traditional, approach to healing; and his essential devotion to the materially poor and needy lent him a compelling attractiveness that mitigated the social instability and poverty of the period. Although the cult incorporates middle- and upper-class believers, the majority of Niño's followers

have always been drawn from the materially poor and working classes. In a time of shifting and conflicting political and economic forces, the Niño's life and healing works came to represent an answer to the impositions of change over which people had little control. Niño was— and in his spirit-form still is—a doctor to those who needed him.

Certainly there are particular historical circumstances that shape his appeal, but the Niño's cult is also an aspect of the generally widespread and very old traditions of folk religion and folk medicine in Mexico. The pervasive and systemic nature of Catholicism in complex greater Mexican societies does not allow for a sharp division between folk and official religion; rather, the folk religious practices of *fidencistas* are best described as an unsanctioned interpretation and expression of Catholicism that is often combined with participation in the official church. In Mexico, folk Catholicism is keyed by traditional kinds of ritual performance (e.g., processions, rogations, dramatic enactments, and so on) and by the cult of the saints manifested in the centrality of the power of holy images. These images, representing various saints, Christ, and the Virgin, function as local patrons in villages, towns, neighborhoods, and cities and as personal patrons of individuals who choose them and relate to them personally.[7]

Both religious performance and holy images allow for a high degree of choice and flexibility that govern belief in the supernatural. In Mexican Catholicism, which has never been bound by dogma or convention, local traditions supercede universal prescriptions, retaining a quality of subjectivity, creativity, and autonomy that is exemplified by the popular acclamation of Niño Fidencio's sainthood.

Quite often the subjective dimension of Mexican folk religion is located in strategies of physical and emotional survival. Folk religion generally is of the body and the image of the body, such as we find in the pained body of

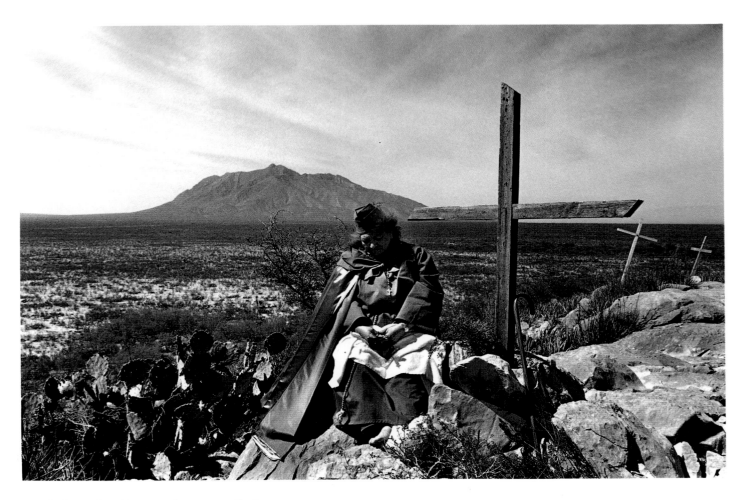

Materia *Emma Gonzáles, cerro de campana, Espinazo, 1991.*

Christ. It is a religion performed and felt in a physical way: the body and the material world take precedence in manifesting the powers of the spirit. In a very crucial sense, folk religion places the extremes of bodily pain and ecstasy at the source of or in conjunction with religious belief. That is, in part, why much of Mexican folk Catholicism is healing-based. Miracles that restore the health of the body become primary signifiers of the worthiness of faith and the actuality of belief.

Thus, Mexican traditions of folk belief and of folk medicine are deeply, often inextricably entwined. A good *curandero* is a man of faith. In his role as a *curandero*, Niño Fidencio brought traditional curative skills and spiritual knowledge to the service of the sick, but because he was so unusually skilled, Niño's healing powers eventually came to be interpreted as manifestations of his special spiritual grace. He became a folk saint, one whose restorative powers could be called upon even after his death. Today, Niño's followers fully believe that he has never left them. They continue a tradition that is centered in the art of healing and performing curative miracles, powerful interventions of the spirit working for the body.

125

Materias: The Chosen of Niño Fidencio

Fidencistas are served by specially chosen practitioners called *materias* or *cajones* who act as willing bodily mediums, or channels, for Niño's spirit. *Materias* maintain that only Niño had the power to heal directly. They say that they themselves cannot heal, but they can channel the Niño's curative powers as well as his counsel and his prophecies. They think of themselves as being chosen or elected by Niño to the task of healing in his name. They are *vasos preferidos* (chosen vessels) or *cajitas* (little boxes) that accept the spirit of Fidencio and make it available to others. Most *materias* come into the cult as a result of a miracle performed for them by the Niño, which they take as a sign of Niño's desire for them to work for him.

Miracles are a source of new identity for the *materia*. Once a miracle is enacted, the one who sought it from Niño is changed forever. A *materia* then belongs to Niño, and this sense of belonging provokes a shift from a single to a corporate self who is capable of holding the Niño's identity as well as the *materia*'s personal identity. As one *materia* expresses it, Niño comes "looking for hearts" that are big enough to hold his heart as well.

Many of Niño's believers and the majority of *materias* are women, a preponderance that is consistent with folk Catholic religious practices in Mexican mestizo culture in general. To be sure, men have an important role as both followers and healers in the *fidencista* movement, but the Niño's cult continues to draw more women than men.[8]

Because the calling to become a *materia* comes directly from Niño, any sacrifice for a relationship with him is made willingly. Yet many *materias* suffer a certain conflict with conventional male authority that sometimes poses a challenge to their devotion. *Materias* also express concern over disagreements with their parish priests, who sometimes disapprove of participation in the cult. Ultimately, though, these women and their male counterparts prevail against convention in their assertion of the Niño's cause.

Materias gather their own followers around them. Some of the well-established and esteemed mediums have hundreds of people under their direction and care, but most serve only a very local group of *fidencistas*. Each *materia* establishes a *misión*, usually at her home, consisting in a room dedicated exclusively to serving the Niño's spirit. Such rooms are elaborately decorated and feature a large central altar called a *tronito* (throne) where photographs and statuary depicting the Niño are featured among various images of Christ, Our Lady of Guadalupe, the Virgin of San Juan, Saint Martin, and other saints mingled with candles, crosses, jars of holy water, family pictures, mementos, and other miscellany. The *materia* holds weekly gatherings in the throne room and there performs *curaciones* (curing ceremonies).

In trance, the *materia* assumes both the spirit and the role of Niño Fidencio, dressing in a white robe and hat imitative of the dress Niño himself wore in his later years. The *materia*, addressed during the *curación* as "he" or "Niño," may experience a voice change—a raise in pitch—that suggests Niño's voice and indicates the change in identity. The trance-induced gender switch is made more complex by the fact that Niño himself was a somewhat feminine man whose authority rested not in typical demonstrations of assertive masculinity but in appropriations of feminine conventions such as care and nurturance.

In her role as Niño, the *materia* assesses the need for a healing and proceeds accordingly by her own understanding of how the Niño is using her to effect a cure. This requires power, skill, imagination, and intuitiveness. Like the Niño himself, *materias* are ingenious in the practice of healing rituals. Rituals are said to be directed by the

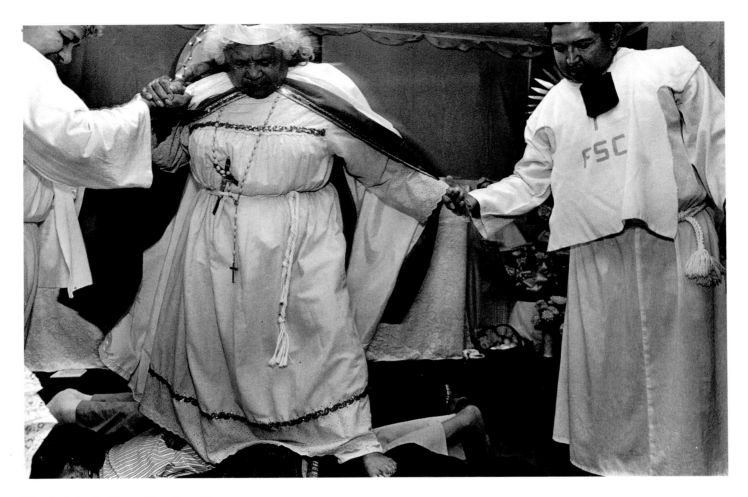

Materia *Anita Rodríguez, Rosenberg, Texas, 1990.*

Niño through the *materia*, but often they take on a unique quality of individual invention and spontaneity. Healings often involve physical manipulations, such as massage with oil or touching of the head. Always there is the requirement of a desire to meet the demands of working hard to channel Niño's spirit to miraculous ends.

In moments of trancing and curing, when a *materia* is fully available to the Niño's influence, gender boundaries become fluid. The interplay of masculine and feminine elements shifts the dimensions of power available in any particular *curación*; different kinds of power become available simultaneously. At once, a woman who is curing can manifest stereotypical masculine authority while coaxing and nurturing—traditional feminine traits—a healing into being. For women in particular, belief in the Niño can operate as a strategy of rebellion and self-fulfillment that counters the effects of male dominance in their lives. The institutionalized authority of husbands, doctors, and priests—the most profound representatives of the patriarchal order in a Mexican woman's life—is challenged by devotion to Niño, a man who on many levels represents the transformative power of difference.

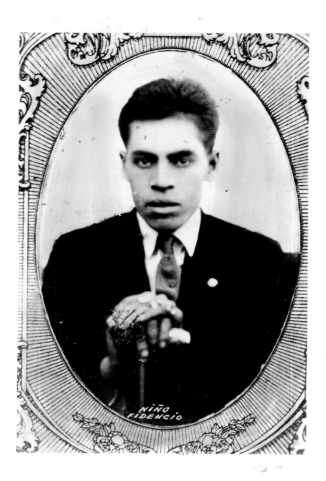

NIÑO FIDENCIO

extraordinary range of photos of the Niño, taken during the period of his life's mission, has been the basis for his popularization to this day. They include formal portraits, dramatic setups, and documentations of curing practices. These prized photos, often spoken of in the most intimate terms as if they were taken by the owner or a member of the family who was there with the Niño when a miracle occurred, are at the center of altars dedicated to the saint; they are displayed in consort with family pictures and alongside snapshots of current cult practices, such as healings and pilgrimages to Espinazo; they are shared as testimonies of belief in Niño's powers; and they are cherished as remembrances of the Niño's actual physical contact with his believers.

Perhaps the most widely replicated image of Niño is a portrait of him as a young man—not older than twenty years—seated wearing a black suit, white shirt, and tie. Despite the urban and Anglo conventions of his costume, Fidencio's facial features are markedly indigenous and his gaze direct and somber. This image, reproduced on holy cards, buttons, postcards, candles, T-shirts, key rings, and elsewhere, has gained the status of an icon, not unlike the standardized saints' images found throughout the world.

Another of the widely popular images is a highly dramatic picture of Niño standing in the aura of Our Lady of Guadalupe, accomplished by collaging Niño's photograph into a standard lithographic print of the Virgin. It is not known why or when, but either Niño himself or others gave him the epithet *El Niño Guadalupaño* (Child of Guadalupe). Perhaps he considered Her his special patron.

No other Mexican folk saint has been so represented, assuming the mantle of the patron saint of Mexico and one of the singularly most powerful manifestations of the Virgin Mary in the world. The Niño is represented as a

Photography and Belief

His humility aside, Niño Fidencio seems to have understood the importance of creating and maintaining visual images of himself that would last in the memories of his followers. Testimony suggests that while he was still alive Niño allowed at least one man to make and sell clay statues of his likeness.

Photography presented an even better way to be remembered. A telling photograph taken in 1928 shows a broadly smiling Niño gathered with a crowd in front of the *pirulito* tree festooned with his photographic image. An

channel for Guadalupe's healing power and also as a national figure, the Son of the Virgin who symbolizes *mejicanismo* (the sense of being Mexican). At the same time, this image renders Niño Christ-like in its depiction of him as an adult male shown in the conventional pose of Christ displaying His Sacred Heart. This remarkable portrayal allows a simultaneously ruptured and integrated male-female image of the Niño. He is Christ and the Virgin at once. Niño's femininity—a potentially troubling aspect of his persona—is absolved by reading it through the Virgin's consoling and protective image, while his masculinity is enhanced by its reading through conventional body language associated with Christ giving salvific benediction.

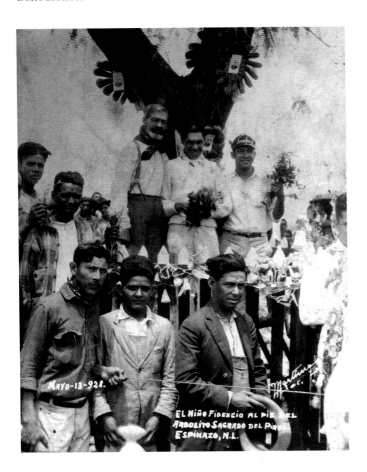

Other cherished photographs circulated within the network of Niño's missions are used by individual *fidencistas* to document his sacred status. Photos taken throughout his lifetime naturally mark physical changes in the way he looked over the years, but for some followers these differences are noted as further proof of Niño's saintliness:

They say the reason the Niño looks different in the old pictures was because he was overcome by the Holy Spirit, and when you are a saint you don't ever look the same way—you change your appearances—and because of this photography we catch this change in appearances (Francisca Monsiváiz Aguirre [Panchita], San Antonio, Texas). Physical changes in the body that the camera captures without judgment are here assessed as a declaration of Niño's sainthood.

Another *materia*, Nicholosa Henry, compares photos of Niño with visions she has had of him while in trance. It is typical for *materias* to see very clear visions of the Niño during *curaciones* and at other times as well. In many ways the cult is defined by the continuing visual presence of the Niño in his followers' lives. He is not only a spirit working through them, he actually appears to his followers giving them instruction, guidance, and blessing.

Accepting the reality of these visions is part of becoming a *materia*. After narrating her history and the many events, including visions, that led her to the Niño, Nicholosa Henry concludes by saying, "Now I can see him as clear as I can see him in the pictures." Photos of him operate as parallels to visions of the Niño. For Sra. Henry a picture is a true expression of the Niño's presence and lends credibility and comprehension to her visions of him; the two visual forms complement and enhance one another.

Because the *fidencista* movement places such strong emphasis on healing and curing, stories told about Niño and reasons given for believing in him focus on the impor-

tance of his healing abilities. There are many documentary photos of the Niño in the act of curing, especially removing tumors (a visible manifestation of illness that can be easily photographed). The camera seems to have become an adjunct instrument in healings, marking the historical moment of a miracle and making it demonstrably real.

In current practice, *fidencistas* are keenly aware of the camera's availability to them as an instrument for recording miraculous events. Many *materias* own inexpensive cameras and take pictures on pilgrimage to Espinazo, during curings, and at other gatherings of *fidencistas*. These image-documents become part of testimonies of belief. A *materia* in San Antonio takes a snapshot picture of every person she heals then frames these together in a collage that she uses as a visual record of her ability to heal through the Niño's spirit: "All these are my miracles. Each one a miracle."

In a certain way, photos of the Niño's miraculous acts are reminiscent of a certain kind of folk-made ex-voto, in this case the hand-painted scenes that record the event of a miracle and are given in thanks as a testimony to a saint or the Virgin. The practice of making and presenting votive images is very old and includes a range of types, such as the Spanish-derived *milagros* and the *watums* of Poland. In Mexico the tradition is widespread; votive plaques recording miraculous events are to this day found heaped up on church side altars throughout the country.

For hundreds of years the votive plaque has served as a kind of "snapshot" depicting as accurately as possible the scenic details and particular moment of a miracle. Even in their crudest form, votive plaques attempt to capture the verisimilitude of a miraculous event. The ex-voto testifies to the reality and effectiveness of faith in the saints.[9]

Followers of Niño Fidencio rarely create handmade testimonies of this kind. For them, photos have taken over

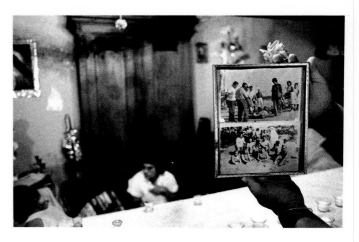

Riojas family mission, Austin, Texas, 1990.

in representing the story and impact of a miraculous healing. In fact, unlike any other form of representation, photos are imbued with the sense of being real and, therefore, truthful. Based on the premise that miracles are real, believers understand the photo as a copy of that reality. What is framed within a photograph is said to have truly "happened."

Whereas the traditional ex-voto, though markedly precise in the details of its renderings, records only the memory of a miraculous event, the photo records its actual occurrence in time. And differently, too, the ex-voto is generally a singular, individually made rendition of a miracle while the photographic ex-voto is a reproduction of the "real" moment of a miracle, a moment that through the mechanics of the photographic medium can be limitlessly copied and recycled.

Photos of the Niño's miracles retain a lineage in the Catholic tradition of using images to enhance and verify belief. In fact, that lineage crosses one of the oldest and most profound debates in Christendom: the relevance to belief of the *vera ikon*, or true image.[10] The church institution has the authority to nominate those true images (for example, the picture of Our Lady of Guadalupe miracu-

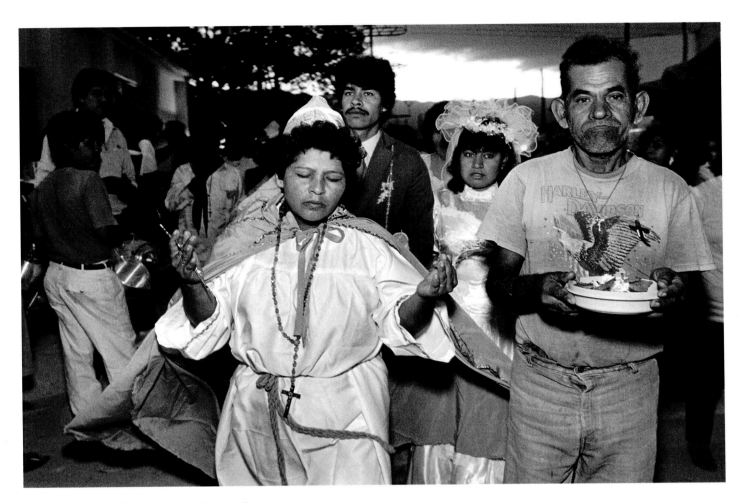

Wedding procession, Espinazo, Nuevo León, 1989.

lously imprinted on Juan Diego's cape), considered to be God-given visual impressions that are worthy of veneration. In the folk practice of Catholicism, however, unsanctioned images, just like unsanctioned saints, play their part in the ever-evolving drama of lived religious experience. For *fidencistas*, particular photos of Niño capture the truth of his miracles and serve as a type of *vera ikon*.

The age-old controversy over the authenticity of "true images" reaches a new level of complexity in the modern era of the camera. We all live in the camera-ready age of instantly available images—from family snapshots to fashion spreads, from advertising come-ons to music videos, from newspaper documents to motion picture and television fantasies. All of these create a constant flow and fluctuating pattern of multiple images that we absorb and evaluate, choose to ignore, discard with disgust, adore unwittingly, or mark as true expressions of meaning in our lives. In both sacred and secular realms we select out images to believe in. More than ever before, the nature of a "true image" has become an aspect of personal choice. This is perhaps nowhere more profoundly evident than in the acclaim given to beloved photos of Niño Fidencio.

The usefulness of the photograph for *fidencistas* is captured in the fact that any photograph betokens both an absence and a presence, a moment gone by and a moment preserved. Within the division between absence and presence, the photograph becomes a potent means for interpreting the past and the present. For *fidencistas* this can mean a way of knowing that Niño both *was there* and *is here*. The photograph affords the simultaneous absorption of multiple meanings.

Conclusion: Niño's Continuing Presence

One of the central and most endearing symbols of Christianity is the heart. The image of the heart, whether crowned, pierced, garlanded, or inflamed, captures the emotions associated with belief—the deep feelings of love, compassion, courage, passion, sorrow, pain, devotion, and joy that give religion its tremendous impact in human life. The heart is the part of the body that symbolically lives on beyond separation and death. The Sacred Heart of Jesus and the Sacred Heart of Mary are profound images of the continuing presence of these holy figures in the lives of Mexican Catholics.

No less so for *fidencistas*, the heart is a sacred vessel that holds the spirit and presence of Niño Fidencio. *Fidencistas* speak of feeling the Niño in their hearts; that is where he dwells. And when Niño comes through a *materia* to claim a believer, that believer becomes one of the hearts that will serve the Niño. Those who come to him come to his living heart, his living presence, and he enters their hearts for all time.

The Niño's influence continues to grow and be felt in the Mexican community because he has never left his believers. Not only is his spirit alive in the performance of healing miracles but his very presence—his image, his voice, his embodiment, his heart—is constantly renewed

and made available through the *materias* who accept the call to serve Niño. Unlike other saints who after their death can be recalled only through pictorial representation, Niño lives on through photographic documentation and in the living bodies of those who accept his spirit and minister not only in his name but in his likeness.

In fact, the power and continuing growth of the *fidencista* movement is very much vested in the pertinence of Niño's ever-evolving story; the term "living legend" could not be more adequately applied to anyone. Niño Fidencio is constantly revived and invigorated by way of activities and images that store his historical memory and restore his living presence in the hearts and lives of his believers. Miracles, cures, legends, testimonies, stories, pilgrimages, photos, altars, feast days, costumes, ceremonies, and songs create a fluid proliferation of means for constantly inventing and reinventing the life and meaning of Niño.

Moreover, the *fidencista* movement lends overwhelming evidence of the vitality and pertinence of folk religious belief in our era—the modern era—that has become synonymous with the so-called death of God. To the contrary, *fidencistas* make a profound claim for the continuing presence of the godly, the holy, the miraculous in everyday life. In addition, they assert the importance and viability of medical practices that are nurtured and refined not by science but by long-standing cultural traditions of curing that treat the body and spirit as one inseparable entity. Yoked together by their mutually beloved traditions of faith and healing and their recognition of a saint who is truly their own, *fidencistas* on both sides of the Rio Grande, by their belief, bridge many borders.

Notes

1. Excellent resources on the history and meaning of the cult of the saints in Christianity are to be found in Brown 1981 and in Weinstein and Bell 1982.

2. For a broad and very useful discussion on the history of image production and veneration in the Christian tradition see Freedberg 1989. A full-length and engaging study of pilgrimage in the Catholic tradition is to be found in Turner and Turner 1978.

3. In addition to her photographic project, Dore Gardner has collected invaluable and much-needed firsthand reports and commentaries from *fidencistas*, a selection of which appear in this book. A full-length study of Niño Fidencio and his cult remains to be done. Currently available written information and history are either cursory or questionable in terms of accuracy. Macklin 1973 and 1974 and Romano 1965 provide sources on folk sainthood and traditional healing in northern Mexico and Texas. Macklin has studied the Fidencio movement as well as other Mexican folk saints while Romano has concentrated on the south Texas saint Don Pedrito Jaramillo.

4. An excellent introduction to *curanderismo* is found in Trotter 1981.

5. It has been suggested that outside observers found Niño Fidencio soft and effeminate in his behavior. Anthropologist June Macklin discusses Niño's feminine identification, saying that he never married; that he was called "mama" by children under his care; that he disguised himself as a woman to escape crowds; and that he wore a *bata* (long gown) instead of customary clothing for men (1980: 145). However, it should be noted that within the circle of his believers Niño's ways are thought of as special, perhaps unusual, not effeminate.

But if indeed Niño Fidencio exhibited somewhat feminine behavior, this is not as unusual as it may seem. While institutional Catholicism does not invite—in fact, prohibits—alternative gender patterns, many traditional healing and belief systems (for instance, aspects of shamanism and North American Indian berdache) include male to female transvestism and other forms of gender transference or reversal. For instance, the Zuni people incorporate a concept of "third gender," the man-woman, who is also represented religiously in the pantheon of gods and in sacred ceremony and dance. See Roscoe 1991 for a full historical ethnography of the Zuni berdache and of its most famous practitioner, the nineteenth-century man-woman called We'wha.

Within Mexican Catholicism, Niño Fidencio's alleged femininity is quite unique, even subversive. Yet his marginal status can be read more understandably within the framework of world religious practices wherein extraordinary accomplishments in healing such as Niño's are effected in part through the theater of gender manipulation. In the folk traditions of curing—current traditions that nonetheless extend deep into the historical past, predating major religions such as Christianity—gender fluidity on the part of the healer often represents and potentiates the crossing of physical and psychic boundaries that enables a cure or a conversion of some sort to take place. In traditional cultures, crossing boundaries is an active metaphor both for the art of curing and the act of believing. Charismatic healers such as Niño Fidencio are known within their cultural groups to have special knowledge and special capacities that are enhanced, not diminished, by their ability to bend and destabilize the boundaries of gender.

6. Among others who have suggested that Niño Fidencio was interested in and may have practiced the popular occultism of the early twentieth century is Richard Zelade, a student of the Niño's cult and a relative of the family that currently owns the hacienda in Espinazo. See Zelade 1987 for further discussion of this aspect of Niño Fidencio's eclectic healing practice.

7. The unofficial and individual aspects of folk religion in Mexico were first discussed by Robert Redfield (1941) in his analysis of the separation between formal Catholicism and folk Catholicism in the Yucatán. Additional sources on Hispanic folk Catholicism are found in Christian 1972, 1981; Ingham 1989; and Turner 1990. For an interpretation of the subjective, creative, and subversive potential of folk religion in class-stratified societies see Maduro 1982.

8. Further resources on the role of women in Mexican and Mexican-American folk Catholicism are available in Anzaldúa 1987; Macklin 1980; and Turner 1990.

9. See Wroth 1982 for an excellent introduction to sacred Catholic folk art. For further information and documentation of Mexican votive plaques see Giffords 1974. Consult Freedberg 1989 for a provocative discussion of the history and meaning of different types of votives.

10. The history and meaning of the *vera ikon* in Christianity are thoroughly discussed in Kuryluk 1991.

Works Cited

Peter Brown. *The Cult of the Saints* (Chicago: University of Chicago Press, 1981).

William A. Christian, Jr. *Person and God in a Spanish Valley* (New
 York: Seminar Press, 1972).

————. *Local Religion in Sixteenth-Century Spain* (Princeton:
 Princeton University Press, 1981).

David Freedberg. *The Power of Images: Studies in the History and
 Theory of Response* (Chicago: University of Chicago Press, 1989).

Gloria Kay Giffords. *Mexican Folk Retablos: Masterpieces on Tin*
 (Tucson: University of Arizona Press, 1974).

John M. Ingham. *Mary, Michael, and Lucifer: Folk Catholicism in
 Central Mexico* (Austin: University of Texas Press, 1989).

Ewa Kuryluk. *Veronica and Her Cloth: History, Symbolism, and
 Structure of a "True" Image* (Oxford: Basil Blackwell, 1991).

June Macklin. "Three North Mexican Folk Saint Movements."
 Comparative Studies in Society and History 15, 1 (1973): 89–
 105.

————. "Folk Saints, Healers, and Spiritist Cults in Northern
 Mexico." *Revista Interamericana* 3, 4 (1974): 351–367.

————. "'All the Good and Bad in This World': Women, Traditional
 Medicine, and Mexican American Culture." In *Twice a Minority:
 Mexican American Women*. Margarita B. Melville, ed. (St. Louis:
 C. V. Mosby Co., 1980), pp. 127–148.

Otto Maduro. *Religion and Social Conflicts* (Maryknoll, NY: Orbis
 Books, 1982).

Robert Redfield. *The Folk Culture of Yucatán* (Chicago: University of
 Chicago Press, 1941).

Octavio Romano. "Charismatic Medicine, Folk-Healing, and Folk
 Sainthood." *American Anthropologist* 67 (1965): 1151–1173.

Will Roscoe. *The Zuni Man-Woman* (Albuquerque: University
 of New Mexico Press, 1991).

Robert T. Trotter. *Curanderismo* (Athens: University of Georgia
 Press, 1981).

Kay Turner. "Mexican American Women's Home Altars: The Art of
 Relationship." Unpublished doctoral dissertation, University of
 Texas, 1990.

Victor Turner and Edith Turner. *Image and Pilgrimage in Christian
 Culture* (New York: Columbia University Press, 1978).

Donald Weinstein and Rudolph M. Bell. *Saints and Society* (Chicago:
 University of Chicago Press, 1982).

William Wroth. *Christian Images in Hispanic New Mexico* (Colorado
 Springs: Taylor Museum, 1982).

Richard Zelade. "El Niño." *Third Coast Magazine* (May 1987): 35–
 38, 56–57.

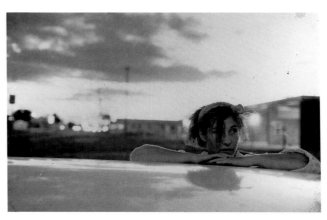

Dore Gardner began working as a documentary photographer in the late 1970s. Among many exhibitions of her work is the forthcoming "Niño Fidencio: A Heart Thrown Open," a major traveling exhibition organized by the Houston Center for Photography (1993). She lives in Marblehead, Massachusetts.

Kay F. Turner, Ph.D., is a folklore consultant in Austin, Texas. She is a member of the American Folklore Society and has written and published widely in the area of Mexican folklore. She has acted as curator and curatorial consultant throughout the country and is the author, with Pat Jasper, of the catalog *Art Among Us/ Arte Entre Nosotros: Mexican American Folk Art in San Antonio* for the San Antonio Museum of Art. Between 1985 and 1990 she was Associate Director of Texas Folklife Resources in Austin.

5 4 3 2 1

Project editor: Mary Wachs
Designer: Eleanor Morris Caponigro; jacket by Linda Seals.
Composition: Set in Bauer Bodoni by Wilsted & Taylor

Library of Congress Catalog-in-Publication number: 92–80916
ISBN 0–89013–223–X (clothbound); 0–89013–234–8
(paperbound).

Museum of New Mexico Press
Post Office Box 2087
Santa Fe, New Mexico 98504–2087